M000248202

IMAGES
of America

CALICO

Paige M. Peyton

ARCADIA
PUBLISHING

Copyright © 2012 by Paige M. Peyton
ISBN 978-1-5316-5985-1

Published by Arcadia Publishing
Charleston, South Carolina

Library of Congress Control Number: 2011932657

For all general information, please contact Arcadia Publishing:
Telephone 843-853-2070
Fax 843-853-0044
E-mail sales@arcadiapublishing.com
For customer service and orders:
Toll-Free 1-888-313-2665

Visit us on the Internet at www.arcadiapublishing.com

This book is dedicated to Laura Wortham Bell King
(March 9, 1858–December 14, 1941), California pioneer and "Mother of Calico."

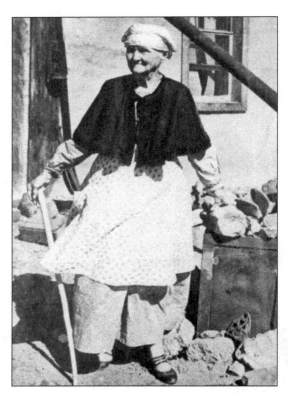

LAURA KING. Here, King is shown outside the Lane House in 1938 at the age of 79. (Courtesy OCA.)

CONTENTS

ACKNOWLEDGMENTS

The historical records used for this book are dispersed among several California archives and personal collections, and I am most grateful for the support and cooperation of each. They are the Betty J. Stohler Collection—Betty J. Stohler, Highland, California and Jerry Stohler, Yucaipa, California; Bureau of Land Management—Susan Sarantopoulos, Sacramento, California; Gardner A. Sage Library, New Brunswick Theological Seminary—Chris Brennan and Dr. Russell Gasero, New Brunswick, New Jersey; Leila Bahten Murton Collection—Sydney Mozingo, Nampa, Idaho; Los Angeles Public Library, WPA Collection—Christina Rice, Los Angeles, California; *Los Angeles Times*—Erica Varela and Ralph Drew, Los Angeles, California; Mojave Desert Archives, Mary Beal and O.A. Russell Collections—Dennis Casebier, Goffs, California; Mojave River Valley Museum (MRVM)—Cliff Walker, Pat Schoffstall, Bob Hilburn, Katie Boyd, and Debie Evans, Barstow, California; Moore and Merritt Family Collection—Frank W. Moore VI, El Dorado Hills, California; Norman Feldheym Library (Feldheym)—Susan Payne, Dave Rutherfurd, and Paul Garrity, San Bernardino, California; Orange County Archives (OCA)—Susan Berumen and Chris Jepsen, Santa Ana, California; San Bernardino County Archaeological Information Center (AIC)—Robin Laska, Redlands, California; San Bernardino County Archives—Genevieve Preston, Kris Kunze, and James Dick, San Bernardino, California; San Bernardino County Surveyor's Office (SBCSO)—David Eickhoff, San Bernardino, California; San Bernardino Historical and Pioneer Society (SBH&PS)—Richard Thompson and Steve Shaw, San Bernardino, California; The Bancroft Library, University of California, Berkeley—Susan Snyder, Lorna Kirwan, Dan Wikey, and Dan Johnston, Berkeley, California; and the US Geological Survey.

Thank you also to Serena Steiner, of Calico Ghost Town, who was kind enough to answer questions about Calico's history and offer comments on the Introduction.

In addition, I would like to acknowledge the comprehensive research conducted on Calico by Roger Hatheway, Dr. Douglas Steeples, and Alan "Lefty" Baltazar. The data from their extensive efforts allowed me to more accurately prepare the captions.

INTRODUCTION

Calico, California, is a former silver-mining camp that was born, lived, and died all on the cusp of the 19th and 20th centuries. Described as "purty as a gal's calico skirt," the town is nestled in the folds of the rainbow-colored hills of San Bernardino County, about 11 miles northeast of Barstow.

Although there were recorded claims earlier, the Calico Hills silver rush and the history of Calico really began on April 6, 1881, with the discovery of pure horn silver along the east flank of King Mountain. The claim was located by six men: Frank Meacham, his uncle George W. "Doc" Yager, San Bernardino County sheriff John C. King, deputies Tom C. Warden and E. Hues Thomas, and Ellis J. Miller, a storeowner who lived near present-day Barstow. Grubstaked by the sheriff in return for a share in anything they found, the men located the Silver King Mine, which eventually became one of the largest and richest silver mines in California.

The first year in the Calicos was difficult. Miners camped in the deep canyon below the mines, slept in tents or open campsites, and had to haul everything in and out on foot or by pack animal. Within the first few months, a devastating spring flood covered the valley floor with mud, forcing the miners to seek higher ground. They chose a narrow, inclined bench to the east, constructed a dirt road up its spine, and on July 5, 1882, the area was officially surveyed for a new townsite—Calico. By October, wagons loaded with lumber and supplies from Daggett were arriving for the construction of houses, stores, and a variety of mining structures.

Between 1881 and 1883, more than 300 claims were marked or recorded in the Calico Hills, and three distinct pockets of mining emerged. The first was north of Calico along and above the steep walls of Wall Street Canyon. Among others, the Silver King, Oriental, Burning Moscow, and Red Cloud Mines were found in this area. About one mile northeast of Calico was East Calico. The Bismarck, Alhambra, Birdseye, and Odessa Mines were located there. The third group of mines was located about a mile to the west, the most famous of which was the Waterloo.

In the winter of 1882–1883, deposits of a white crystalline rock—borax—were discovered in Mule Canyon. The deposits were found by Calico storekeeper Hugh Stevens while prospecting for silver. Stevens had the samples assayed in San Francisco by chemist Thomas Price. Recognizing the value of the samples, Price revealed the results of the assay to William Tell Coleman, who owned borax properties in Nevada and Death Valley. By June 1883, Coleman had secretly purchased all of the borax-containing parcels in Mule Canyon, including those owned by Stevens. Coleman operated the mines using a small workforce from Calico, but by 1888, the company was cash-strapped and was sold to Francis Marion "Borax" Smith. By 1889, there were 120 miners working the property, and Smith had constructed frame bunkhouses, a dining hall, a company store, a "reading room," and cabins for the storekeeper, mine foreman, and their families. Smith also constructed a large home at the head of Mule Canyon for his visits and to entertain investors when they visited the site. He named the settlement Borate.

Between 1890 and 1906, Borate's workforce rose to more than 600, and production grew from 80 to 3,900 tons of refined borax monthly. The most costly part of the effort—transportation to the Daggett depot by a 10-mule-team wagon—was cutting into Smith's profits, and that element of the operation required several transformations. The first was to expand the 10-mule-team rig to a two-man, three-wagon (two for ore, one for water), 20-mule team, which eventually became the widely recognized symbol of the Borax brand name. This innovation cut transportation costs by about half. Anxious to trim even further, Smith imported an enormous steam-powered tractor. Commonly used in lumber camps, the tractor required a crew of three and hauled two specially designed wagons. Partial to the mules, the miners and teamsters thought it would never work, but "Old Dinah" doubled the output of the mule teams. Unfortunately, the experiment only lasted about a year because of constant maintenance and the 2,500 pounds of coal that the tractor consumed on each round trip. The mules returned to Borate and stayed on the job until the railroad was completed from Daggett to Borate in 1898.

After 24 years of successful production, the value of borax was declining and the mines were reaching the end of their productive life. As a result, Smith chose to end his Calico operations and focus on his other mining properties. In 1913, the railroad line and buildings were disassembled, and everything that could be reused was moved to Smith's borax operation in Death Valley.

Concurrent with the borax operations in Mule Canyon, Calico was having its ups and downs. The first of three fires hit the town in 1883 and destroyed about 17 properties. The second fire in 1884 destroyed a single miner's cabin and its occupant Tom Leonard. The last and worst was in 1887 and destroyed about 20 residences and commercial buildings. Each time, there was rebuilding but with less wood and more adobe and stone to act as firebreaks. Several new water wells were installed that reduced the cost of water and haulage, and there were about 75 active businesses in town by 1885. Housing, which was initially in tents, gave way to wood or adobe, and about 200 dwellings—some set into the rocky hillsides—were eventually completed. At its peak between 1886 and 1896, there was also a bustling commercial district that included 22 saloons, several lodging houses and hotels, a post office, a newspaper (the *Calico Print*), a one-room schoolhouse that doubled as a church on Sundays, and a Chinatown in Jackass Gulch (just east of town) with a population of about 40. Although the numbers for the overall mining district are higher, the population of Calico proper fluctuated between a high of 1,200 in 1887 and a low of 2 (John and Lucy Lane) in 1924. At the time that Walter Knott purchased the property in 1951, a sign on the Calico gatepost read, "Pop. 2."

The landscape in the mining areas was also changing. The Silver King Mine built a 90-foot-high trestle and tramway, a 30-stamp mill, and an ore bin that could hold 200 tons. Other mines built long ore chutes and mills, and the narrow gauge Calico Railroad (later called the Waterloo Mine Railroad) was completed in 1888 to haul ore from Calico to the Waterloo Mining Company across the river from Daggett.

When the price of silver plummeted to 65¢ an ounce in 1896, many of the mines closed and most of the miners left for greener pastures. The school and post office were closed in 1898, and several of the town's buildings were moved to either Yermo or Daggett. By 1904, the town was essentially abandoned, although a few hardy stragglers stayed on to work in the borax mines until they closed in 1907. Accounts vary, but between 1881 and 1907, the Calico mines are believed to have produced about $20 million in silver and $9 million in borax.

In 1916, John and Lucy King Lane moved to the nearly deserted Calico where they had lived in the mid-1880s. John and Lucy lived first in the old store that he had purchased from Isaac Norton and later in the old courthouse and post office building, which is now the Lane House and Museum. During their years in Calico, the Lanes were ambassadors of Calico, catering to several film crews from Hollywood, patiently answering questions by the numerous writers who wanted to tell the Calico story, and continuing to mine a few silver claims that were eventually sold to the Zenda Gold Mining Company in 1927. John Lane died in 1934 at the age of 75. Lucy Lane retained their home in Calico until shortly before her death and visited there often, but

also spent time with her family in Julian and Tracy. Lucy Lane died in 1967 at the age of 92; she is buried in Hemet next to her husband.

About 1917, a cyanide plant with large redwood tanks was built by Bert Osborne to recover silver from the old Sioux Mine tailings. Jim Riggs built a second cyanide plant in 1936, but these operations eventually folded, leaving only the Lanes and a few other residents.

Lawrence and Lucille Coke moved to Calico in 1934. The Cokes collected artifacts from around the property, opened a rock shop and museum, and provided tours of the mines to visitors. In 1941, they published a small book about Calico containing entertaining anecdotes about various people and activities. They sold the museum to W.E. "Doc" Smith and his sister Irene Wolfe, of Daggett, in 1947.

In 1951, Walter C. Knott purchased 75 acres in the Calico area with plans to reconstruct the town over a 10-year period. The acreage included the entire town of Calico and several adjacent claims. While homesteading in nearby Newberry Springs, Knott had worked as a carpenter roofing the Calico mills and helped to construct the redwood cyanide tanks. Knott was also the nephew of the same Sheriff John King who provided the grubstake for the first big Calico strike. Ultimately, Knott became best known as the owner/developer of Knott's Berry Farm in Buena Park.

Between 1951 and 1966, the Knotts restored several of the remaining Calico buildings and used old photographs and maps to rebuild the rest of the town, in some cases on the original foundations. The Knotts also located one of the buildings that had been moved when the town was abandoned in the late 1890s and had it hauled back to Calico. Several buildings, including the Doll House and Bottle House, were newly constructed, and a narrow gauge railroad was built and named the Calico & Odessa Railroad. In an article from the May 1961 *Desert Magazine*, Lucile Weight remarked on the Knotts' commitment to the restoration of Calico: "The Knotts do not regard this as a commercial enterprise. They are sure they are putting more money and love into it than will ever be returned. They are doing it for the sake of that spirit which made Calico's days glorious—and for you and me, that we might better appreciate this heritage of our Desert West."

In November 1966, Walter Knott completed the transfer of ownership of the entire 480-acre property to San Bernardino County for operation as a regional park. The county developed the first campground below Calico in 1967 and placed all of the overhead utilities underground in 1973. The Lane House and Museum was opened in 2001, the same year that a fourth Calico fire destroyed five 1950s–1960s-era buildings, all of which have been rebuilt. As a "living" ghost town, Calico operates year-round as a family-friendly destination for Old West and mining enthusiasts of all ages. On November 16, 1962, Calico was designated California Historical Landmark 782 by the Department of Parks and Recreation. On July 8, 2005, Senate Bill 906 was passed recognizing Calico as the official Silver Rush Town for the state of California.

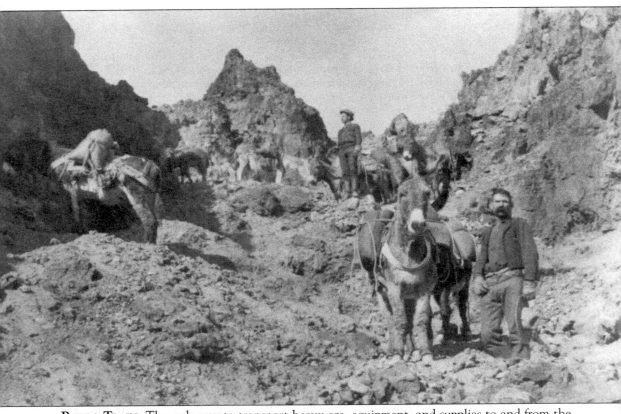

BURRO TRAIN. The only way to transport heavy ore, equipment, and supplies to and from the steep rocky hillsides was to use burros or other pack animals. This unidentified group of miners is hauling ore from one of the more inaccessible mines. (Courtesy OCA.)

One

ALL THAT GLITTERS
IS NOT GOLD

SILVER RUSH IN THE CALICOS

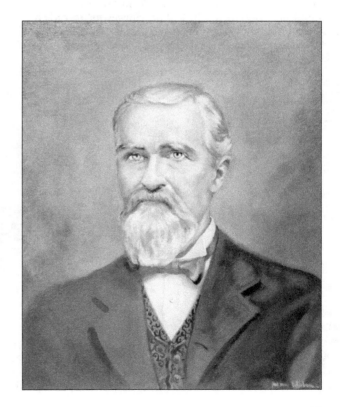

SHERIFF JOHN KING. In the history of Calico, Sheriff John Caleb King (1838–1901) is best remembered as the man who grubstaked the discovery of the Silver King Mine, which set off the California Silver Rush. King was also the uncle of Walter C. Knott, who restored Calico between 1951 and 1966. This portrait of King was painted by Paul von Klieben in the early 1950s. (Courtesy OCA.)

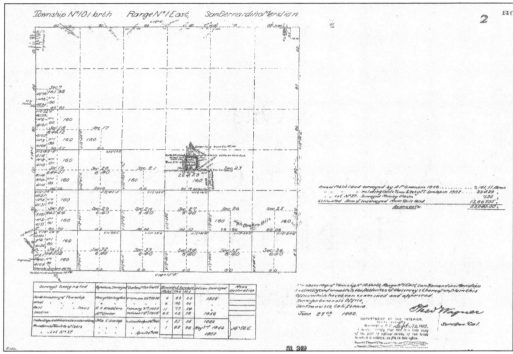

AN 1882 SURVEY MAP. The Joe Miller store shown on this 1882 survey map was one of the first buildings constructed in Calico. Surveyors' records indicate there was no "living water on the townsite or within five or six miles of it." The surveyors also noted seven lumber houses—five for businesses and two for residences—and "quite a number of dugouts in the cliffs, bush shanties, and tents." (Courtesy SBCSO.)

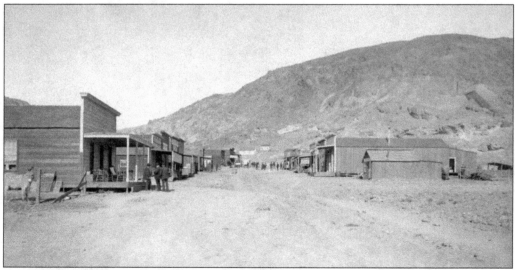

EARLY WOOD BUILDINGS. The first buildings in Calico were constructed of wood. This very early image of the buildings along Main Street was taken prior to the devastating fire of June 1883, which destroyed many of the town's structures. Even with the dust and heat, all of the men in the photograph are wearing suits and hats, which was typical of the era. (Courtesy OCA.)

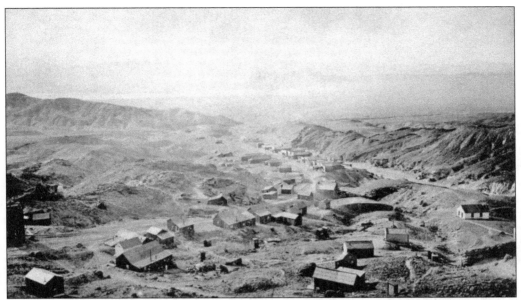

EARLY CALICO FROM ABOVE. After the fire of 1883, every third or fourth building was constructed of rammed-earth adobe to keep future fires from jumping from building to building. A few of them are seen in this image, which dates the photograph to about 1884. The Silver King boardinghouse, also used as the school between 1881 and 1884, is the white building at far right. (Courtesy OCA.)

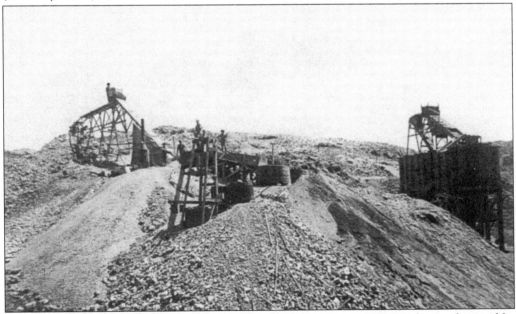

BISMARK MINE AND LEACHING PLANT. The Bismark was located in East Calico and owned by George V. King (Lucy Lane's father), John Sullivan, and James Reed (standing together in the center). In this image from 1886, low-grade ore is being processed in large wood vats to dissolve the silver. The residue was drawn off into canvas bags, pressed into bricks, and sent to a smelter for refining. (Courtesy MRVM.)

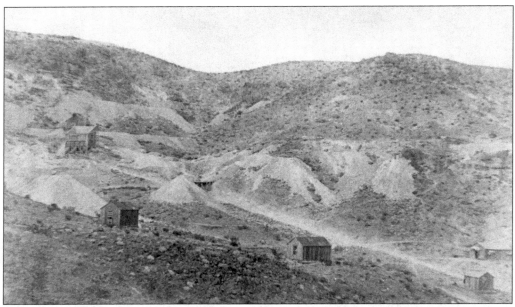

OCCIDENTAL MINES. The Occidental group of mines was owned by the Runover Mining Company and was scattered across the flanks and top of Thunderer Mountain near the Bismark. In this image from 1882, four wood structures and an ore bin are seen in and about the mine tailings. Mrs. William Cochran operated the boardinghouse and provided daily meals for between 75 and 100 men. (Courtesy MRVM.)

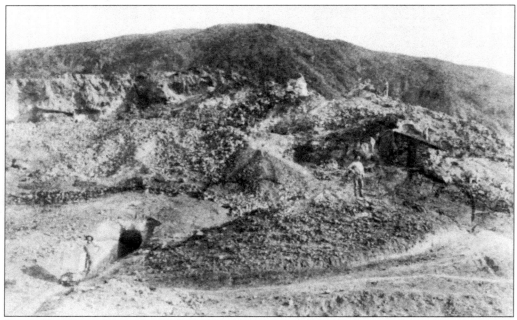

SILVER KING AND ORIENTAL, EARLY 1880s. This early Calico photograph shows the openings to the Silver King and Oriental Mine adits (horizontal shafts). The miner in the left foreground is leaning on an ore car as it leaves the Oriental on a narrow gauge track. The miner at the right is near one of the many hillside rock structures common to the Calico landscape. (Courtesy OCA.)

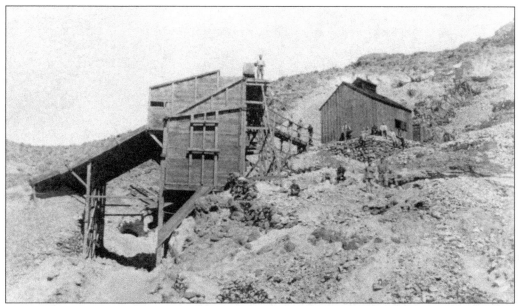

SILVER KING MINE BUILDINGS. This Silver King ore bin (left) and blacksmith shop were located near the top of King Mountain. Mule-drawn wagons pulled under the overhang, and the ore was dropped through the bin's chutes. The blacksmith was one of the most indispensable workers at a mine. Blacksmiths forged the iron tools and drills that made it possible to break through the solid rock. (Courtesy OCA.)

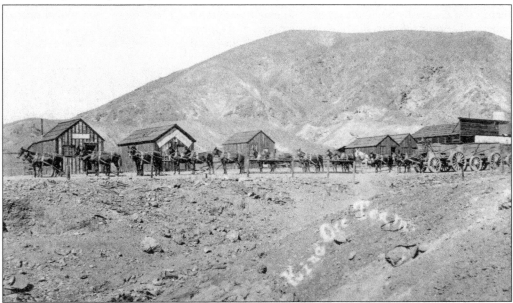

MULE TEAM ON MAIN STREET, 1882. A 20-mule team hauling ore from the Silver King Mine is stopped near the south end of Calico's Main Street. Each wagon weighed 7,800 pounds empty and 45,000 pounds full. They rolled on steel-rimmed, five-foot-tall front wheels and seven-foot-tall rear wheels. When fully rigged, the 20 mules stretched a remarkable 120 feet in front of the wagon. (Courtesy Sydney Mozingo.)

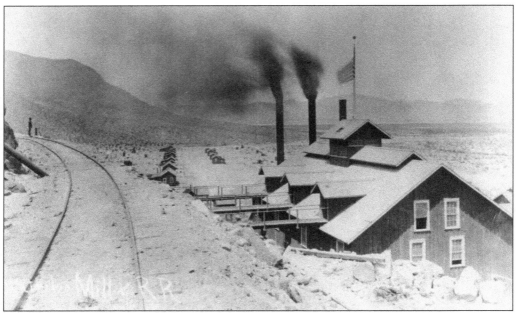

WATERLOO MILLS. By the late 1880s, there were several active ore processing mills supporting the Calico Mining District. Among these were two Waterloo Mills, the first of which was a 16-stamp facility and the second a 60 stamp (above). The Waterloo Mills were located on the south side of what is now known as Elephant Mountain, and the newer of the two was lighted by electricity; Diedrick Bahten was the mill supervisor. Costs to haul ore to the mill by mule team were originally $2.50 a ton, but the mules were replaced by a more economical narrow gauge railroad in 1888. In the photograph of the mill's interior below, James Applewhite, owner of the Applewhite Livery and Lodging House in Calico, is third from the left. (Above, courtesy Feldheym; below, courtesy MRVM.)

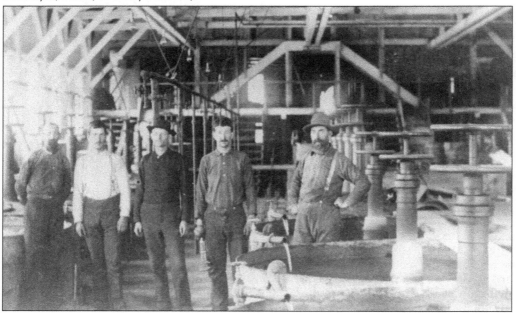

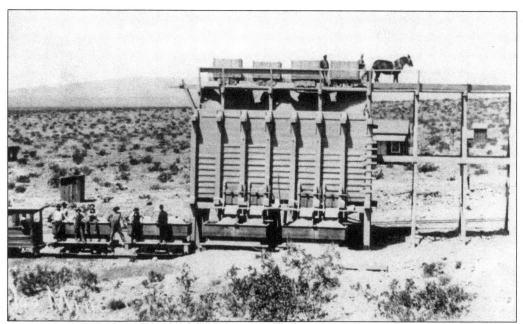

WATERLOO ORE BIN. By 1888, the Waterloo Mine was connected to the Waterloo Mill by a narrow gauge railroad. As shown here, ore was hauled from the mine by mule-drawn ore wagons, emptied into a large bin, and then transferred by rail to the processing mill. Depending on the topography, trestles were often constructed to facilitate the transfer process. (Courtesy Feldheym.)

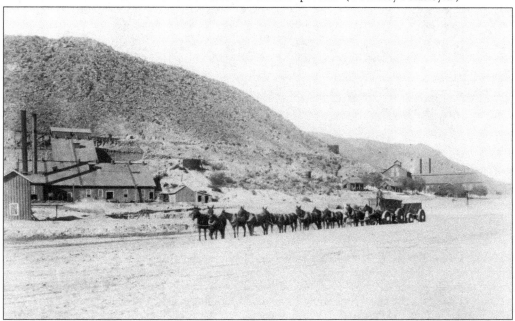

WATERLOO MULE TEAM. This pre-1888 view of the Waterloo Mill is from the Mojave River side of the property. The railroad cut and associated buildings are seen in the mountain face above the buildings, but a 14-mule team hauling two ore wagons is still operating. The sign on the roof of the far mill building reads, "Waterloo Mining Co." (Courtesy OCA.)

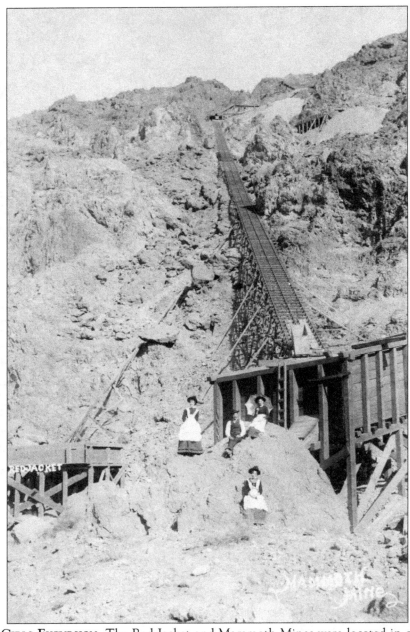

HARVEY GIRLS EXCURSION. The Red Jacket and Mammoth Mines were located in one of the richest areas of King Mountain. In this 1880s image, the women are wearing the distinctive black-and-white uniforms of the Harvey House Girls and were probably on an excursion from Barstow; a second image on the next page shows that the group also visited the Sue (Sioux) Mine. The unidentified man could be a miner, but may also be a chaperone. Harvey Girls lived and worked under very strict rules and were not allowed to travel unescorted. Lucy Lane recalled Harvey Girls visiting Calico in the 1920s when a movie company was filming in Wall Street Canyon. Overwhelmed trying to feed a large film crew, the movie company borrowed two Harvey Girls to help Lane wait on tables. (Courtesy OCA.)

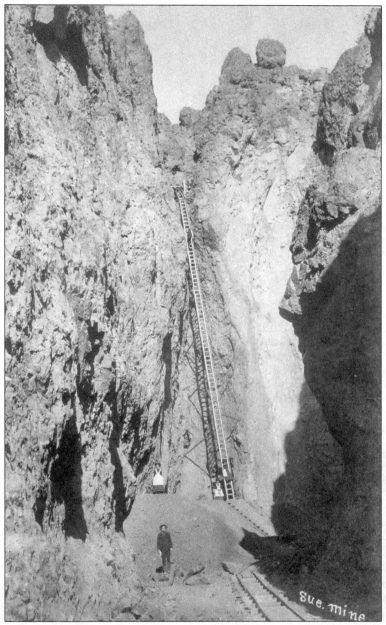

SUE MINE AND LADDER. The Sue (Sioux) Mine was first discovered by John McBride, Lars Silva, and Andy Laswell in 1881. Believing that the mine's deposits were shallow, the three partners sold the mine for $1,600 to Jonas Osborne, a mining engineer from Daggett, but continued to work at the mine as part of the sales agreement. Within a year, the mine had produced more than $60,000 for the new owner. The Sue Mine was among the first recorded in the Calico Mining District. As shown here, the Harvey House Girls also visited this mine during their excursion to Calico. Seated at the bottom of the 92-foot ladder that accessed the mine adit are two of the Harvey Girls; a male companion is perched near the top. (Courtesy The Bancroft Library, University of California, Berkeley.)

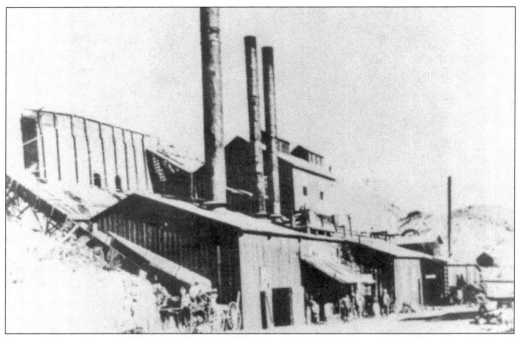

SILVER KING–GARFIELD MILL, 1890. The Silver King Mining Company Ltd. of London, England, owned the Silver King mill. Also known as the Garfield Mill, the 30-stamp facility was located on the south side of the Calico Mountains between Wall Street and Odessa Canyons and processed ores from the Occidental, Odessa, and Oriental groups. William S. Edwards was the manager between 1891 and 1896, when the mill closed. The large tanks of the mill (below) were part of a "Boss" (multiple-pan) system that used chlorination and amalgamation to recover the silver. The timbered walls and tailings from the mill can still be seen on the hillside east of Calico. (Both, courtesy MRVM.)

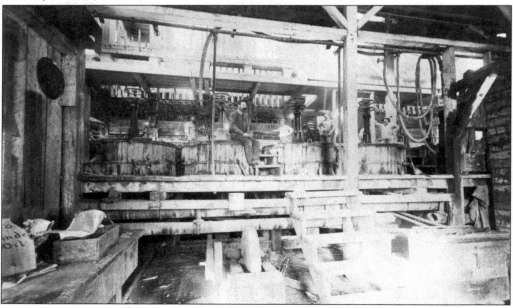

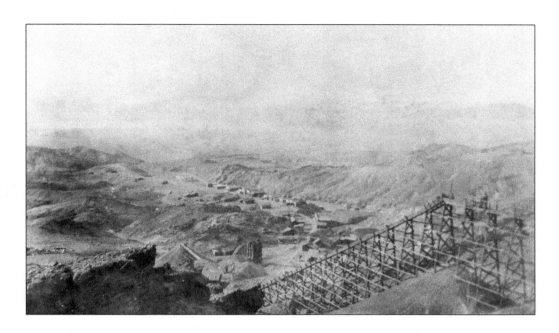

SILVER KING CREW AND TRAM. The Silver King Mine, chute, and ore bin are shown here about 1885. According to Herman Mellen, who helped to build the massive structure, there were originally no safety rails on the trestle to protect workers from the gusty canyon winds. As Mellen put it, "men needed claws like a cat to keep their grip on the trestle while they worked." Mine superintendent Albert Barber did not feel that a safety railing was necessary until he went atop the structure in response to several complaints. After nearly being blown off the rig in a gust, he had the rails installed. Above, two men are standing at the top of the trestle overlooking Calico; below, workers are posing at the bottom of the Silver King chute. (Both, courtesy MRVM.)

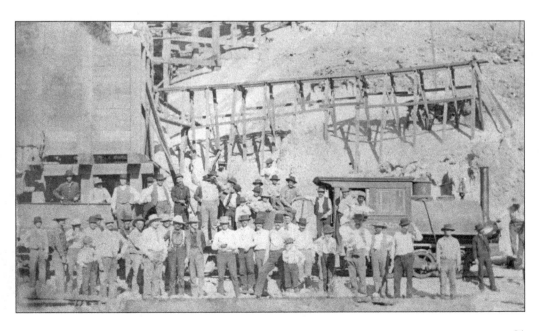

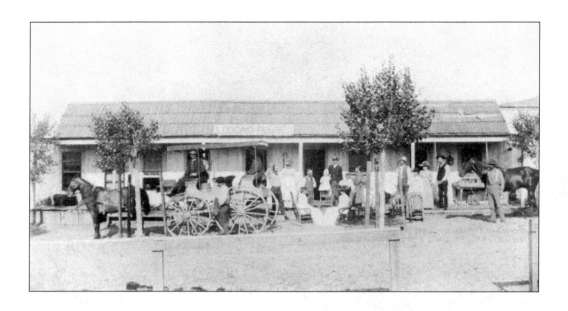

APPLEWHITE BUSINESSES. James M. Applewhite owned the Calico livery (below), and his wife, Ruth Ellen Glenn, operated a white-frame lodging house (above). The lodging house was an 1884 expansion of their original 1883 home. Both businesses were situated on the lower end of Calico but on opposite sides of Main Street. Between 1883 and 1889, the Applewhite Stage, shown above in front of the lodging house, carried men back and forth from the mines to town for lodging and shopping. An advertisement in the October 1884 *Calico Print* notes, "Rooms and lodging, Enlarged Residence, First one on left as you enter Calico from Valley—James Applewhite." (Both, courtesy OCA.)

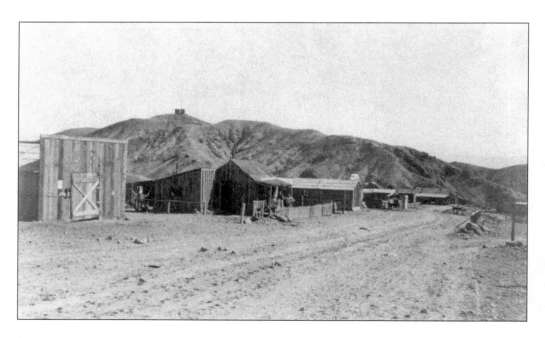

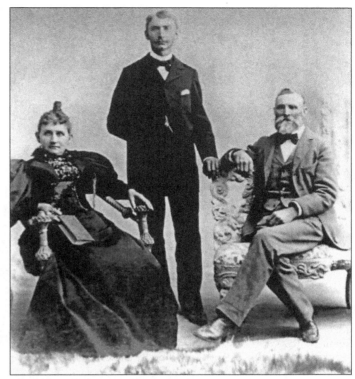

APPLEWHITE PORTRAIT. Calico business owners Ruth Ellen Glenn Applewhite and James Applewhite (seated) and their son Oliver Applewhite are shown in a studio photograph from 1895. The Applewhites moved from the Glenn family ranch in Lytle Creek to Calico in 1883 to join the silver rush but returned to operate the Glenn Ranch in 1899 at the request of Ruth Ellen's mother, Mourning Glenn. (Courtesy Feldheym.)

STEBBINS VISIT. Albert H. Stebbins was manager of the Los Angeles–based Stebbins Dry Concentrator Company, which manufactured table-type ore concentrators. The use of this design at Calico was not successful because of the weight of the ore, but Stebbins was later able to sell his tables for use with borax. In this 1885 image, Stebbins is seen with his wife, Stacy Stebbins, and Nellie Stacy at the Albert Barber home. (Courtesy OCA.)

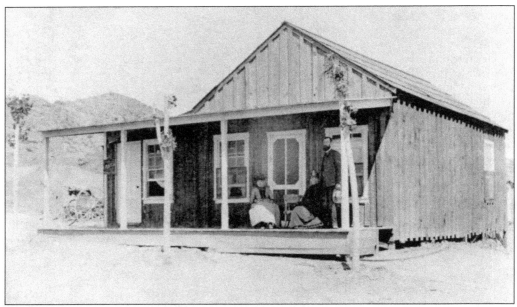

DR. RHEA'S HOME AND OFFICE. Dr. Albert Romeo Rhea was Calico's doctor between 1883 and 1896. He also served as the town's coroner, pharmacist, and the Wells Fargo Express Company agent in 1893. Dr. Rhea is shown above with his wife, Nettie, and Mary Ryan (left), Calico's registered nurse for several years. The Rhea home is on the right; the white door on the left is to Dr. Rhea's office. (Courtesy OCA.)

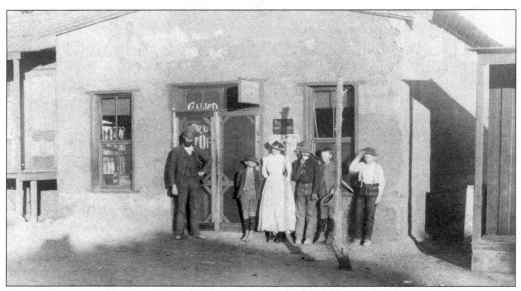

RHEA'S DRUGSTORE. The *Barstow Printer* in 1938 described Dr. Albert Rhea as having once "worked hours to save the life of a worthless drunk." Rhea was quoted as saying, "He owes so much money, I don't dare let him die." Shown here on the left in 1885, Rhea also operated the Calico Drugstore. The woman is Fannie Mulcahy; Rhea's son is to her right. (Courtesy OCA.)

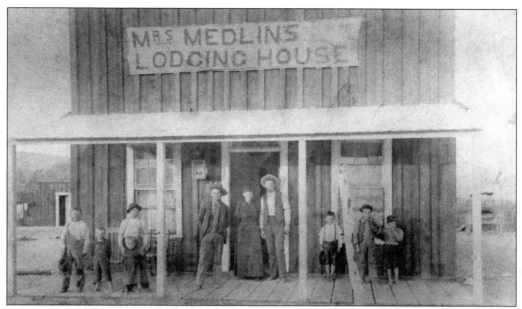

MEDLIN'S LODGING HOUSE. This lodging house was operated by Catherine Malone Medlin (standing in doorway) between 1882 and 1885. Medlin lived in Calico with her husband, Marion, and eight children. The business is first noted in the 1884–1885 Calico Directory but voter registration lists show the family in Calico as early as 1882. The men with Medlin are likely two of her sons, John Lewis and Hall. (Courtesy OCA.)

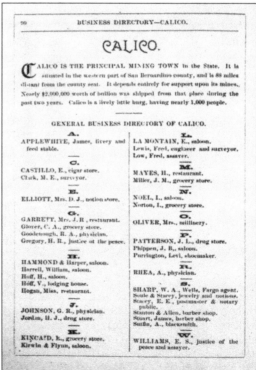

CALICO DIRECTORY, 1886. This page from the San Bernardino County Business Directory, compiled and published by Mac D. White, lists the businesses operating in Calico in 1886. The list shows many of Calico's earliest businesses and pioneers, including Dr. A.R. Rhea, the James Applewhite Livery, three restaurants, four grocery stores (including Joe Miller's store), and six saloons. (Courtesy OCA.)

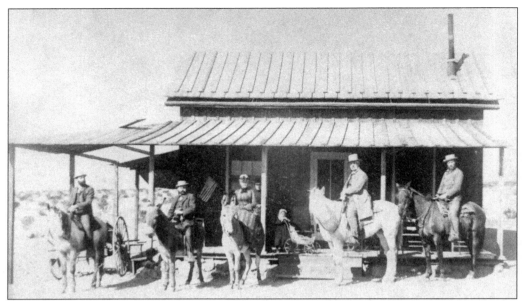

BARBER HOME AND VISITORS. Albert Barber, second from right, moved to Calico about 1882 and built this home and Barber's Mill with his brother George. In this 1895 photograph are, from left to right, superintendent and mining engineer at Barber's Mill Tracy Stebbins, Charles Merritt on his burro Ballam, Mrs. Merritt, Mrs. Merritt's niece (with baby carriage), Albert Barber, and an unidentified man who may be George Barber. (Courtesy MRVM.)

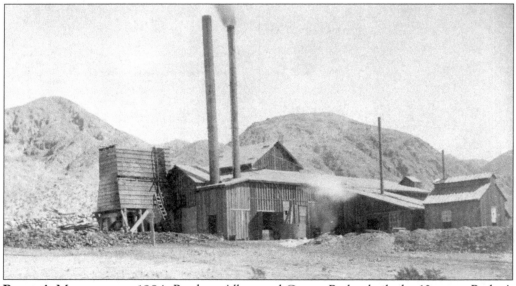

BARBER'S MILL AROUND 1884. Brothers Albert and George Barber built the 10-stamp Barber's Mill between the entrances to Odessa and Mule Canyons. The custom mill operated between about 1883 and 1896; coal to fuel the mill was brought in from New Mexico. About the same time as the Waterloo, Garfield, and Odessa Mines closed for the last time, Barber's Mill was destroyed by fire. (Courtesy MRVM.)

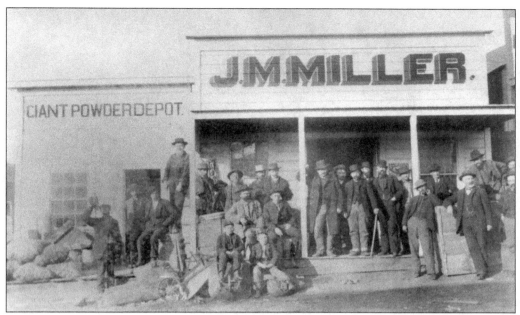

JOE MILLER STORE. Joseph Moore Miller, wife Virginia, and three children moved to Calico in 1881 and built a general merchandise store. Miller's son Charley drove the store's wagon delivering goods to the various mines. The wagon, nicknamed the "Lightning Express," was pulled by two mules—January and February. Shown in this rare photograph, the store burned down in June 1883 along with 16 other businesses. Calico's barber Dick Stanton is standing just left of the left porch window. (Courtesy OCA.)

CHOP HOUSE RESTAURANT. The earliest mention of a restaurant in Calico is from 1882. The *Calico Print* newspaper's July 27 edition from that year mentioned several eateries, including an advertisement for the Globe Chop House, shown here. Boardinghouses and hotels also offered meals. (Courtesy AIC.)

Angeles, Cal. Address, P. O. Box 43.

Globe Chop House.

G. D. BLASDEL: Proprietor.

THIS NEW, ATTRAC-tive and well-finished eating house is now open to the public Meals are promptly and tastefully prepared by an experienced cook at all hours of the day, and from the best edibles that the market affords. The proprietor will spare no pains to please all his patrons, Give him a call, and you will find everything conducted in Metropolitan style.

DELL & THOMPSON

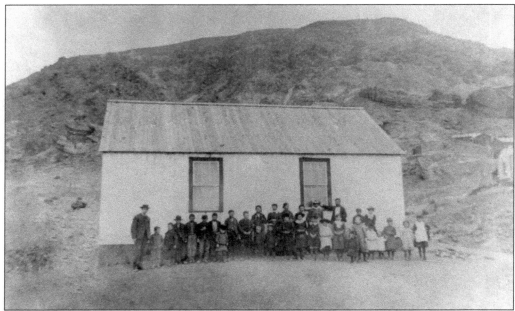

CALICO SCHOOL HOUSES. From 1882 through 1884, Calico's schoolchildren were taught in the white-frame Silver King Mine boardinghouse shown above. A $3,000 bond was issued in 1884 to purchase the land and construct a new school. The new school, its teacher H.H. Heath, and the school's first class are pictured below in 1885. In 1955, the schoolhouse was replicated at its former location by Walter Knott; photographs of the original schoolhouse and recollections of early-day residents were used for the restoration. During the 17 years that classes were conducted in Calico, the average daily attendance varied from 3 to 39. The children walked to the schoolhouse by way of narrow, rugged mountain paths from as far as Occidental and Odessa Canyons nearly two miles away. (Above, courtesy MRVM; below, courtesy OCA.)

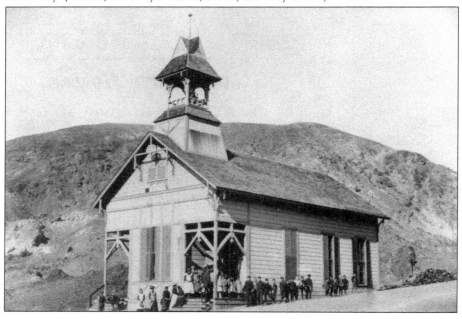

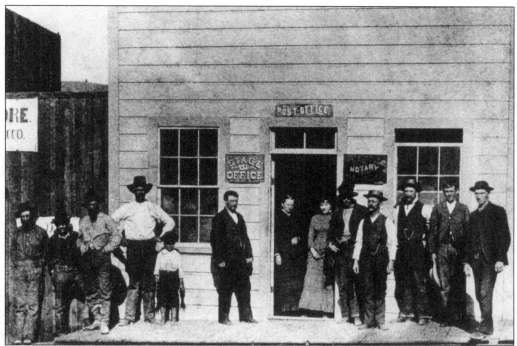

MAIL SERVICE. The Calico Post Office was established on May 18, 1882. Standing under the stage office sign is the first postmaster, William Lloyd Garrison Soule. Standing in the doorway are his wife, Ella (right), and her mother. As shown in the advertisement below from the July 27, 1882, edition of the *Calico Print* newspaper, Soule, a notary public, provided mail service from the Pioneer Grocery Store and stage office that he operated with his partner Everett E. Stacy. Along with the Soule home, the white-frame building was destroyed by the fire of June 1883. Both were soon replaced by adobe buildings. Postal services were discontinued on November 30, 1898. (Above, courtesy MRVM; below, courtesy AIC.)

our own make always on hand.

PIONEER

GROCERY STORE,

Postoffice Building.

A General Assortment of

**Groceries, Miners' Supplies,
Medicines, Etc.**

At No. 10 Calico street, Calico,

W. L. G. SOULE, Proprietor,

Michael Redman.

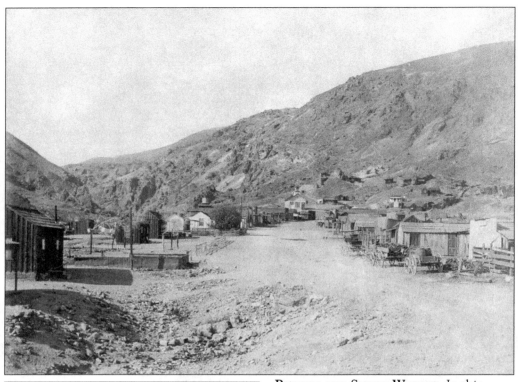

BUGGIES AND SUPPLY WAGONS. In this view of Calico's Main Street, buggies and wagons carrying firewood and water barrels are lined up near the Applewhite Livery and Lodging House. Given the appearance of the town, this image dates to between 1885 when the second schoolhouse was completed (center rear) and before 1887 when the last big fire destroyed most of the town. (Courtesy MRVM.)

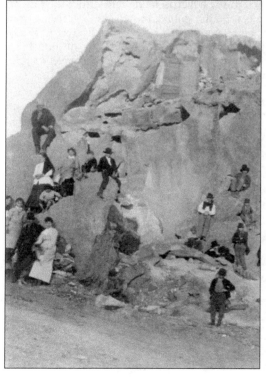

FINE ACCOMMODATIONS. The original Hyena House Hotel was a crude form of miner lodging established in 1881. Shown in this rare image, it was fashioned from holes in the rocks faced with barrel staves. Among its colorful residents was William Harpold, who would meet the stagecoach with a wheelbarrow to take unsuspecting guests and their baggage to the "finest lodging in Calico." (Courtesy MRVM.)

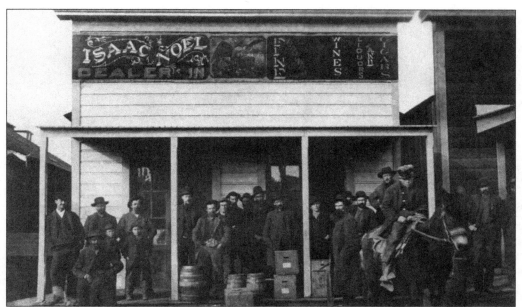

NOEL SALOON 1886. Lot 16 on Calico's Main Street was deeded to Isaac Noel and A.J. Stice on July 21, 1882. The saloon first appears in the July 12, 1882, *Calico Print* advertisement shown below. By 1887, Isaac Noel was listed as the sole owner, and the business was no longer listed by 1888. According to a September 5, 1887, article in the *Los Angeles Times*, the white-frame saloon was destroyed by fire, along with at least 15 other Calico businesses. Among these were the town hall, the Diedrick Bahten lodging house and dwelling, the post office, Miss M.E. Daugherty's Fruit and Confectionery, and the Dickinson & Ball Hotel. (Above, author's personal collection; below, courtesy AIC.)

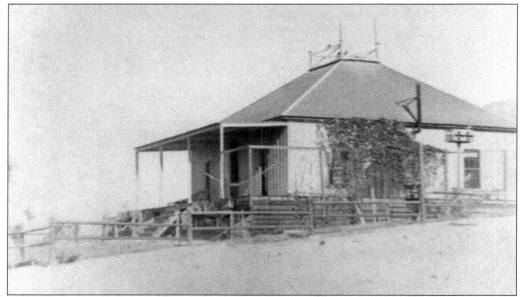

EDWARDS HOME. Shown here in 1891 is the home of William S. Edwards. It was located at the south end of Calico near the town's entrance. Between 1891 and 1896, Edwards was the manager of the Silver King Mining Company's property in Calico. The holdings included the Runover Mine and Mill, which the company purchased for $300,000. (Courtesy MRVM.)

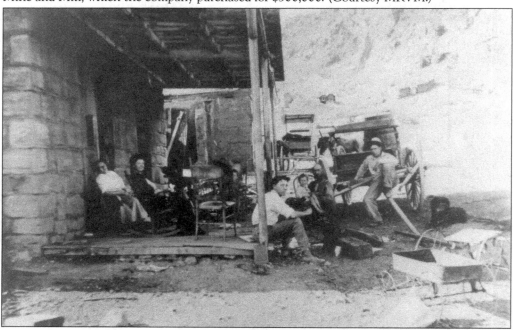

STONE FRONT BUILDING. A replacement for the wood Pioneer Market and post office that was destroyed by fire in 1883, the Stone Front Building was first used as the new post office and later by Thomas Preston and Robert Gribben as a saloon. The building is sometimes referred to as Joe's Saloon. The identities of the people are not confirmed, although various records indicate that some are from the Lane family. (Courtesy MRVM.)

MINING THE RED CLOUD. The Red Cloud Mine was active between 1885 and 1888. In this image taken at the west end of the Mammoth stope, Harry Livingstone is drilling dynamite holes, and Matt Phillips is sorting ore (lower left). Steve Rowe, a mucker whose job it was to load the ore cars and remove debris after blasting, is holding the shovel. Phillips was killed during a cave-in at the Silver King Mine in 1909. (Courtesy OCA.)

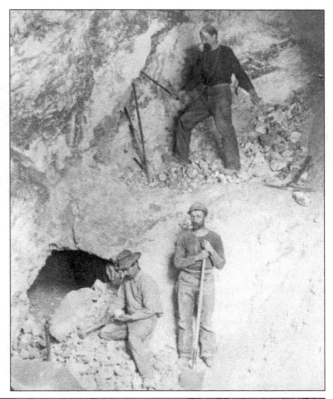

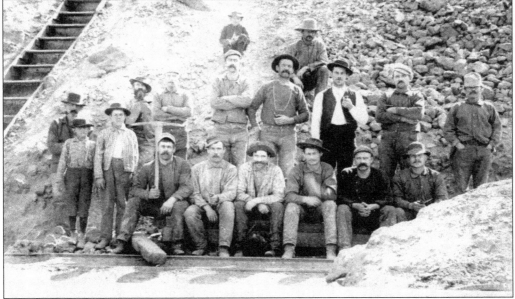

ORIENTAL CARPENTER CREW. This group of miners is posing near the entrance to the ninth level of the Oriental Mine, which was the level of the carpenter's shop. A number of these miners have been identified, including James Obrien (holding the pick) and John Mulcahy (standing far right). The young boy at the top center is Gus Hoban. (Courtesy MRVM.)

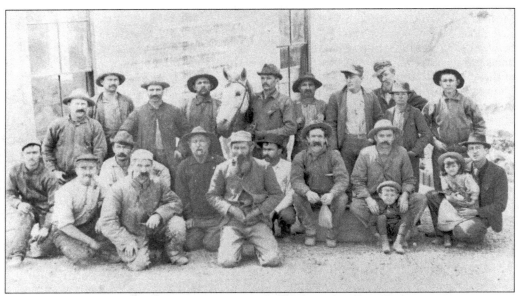

MINERS AT SCHOOL. This Silver King Mine crew is posing in front of the second Calico schoolhouse. The photograph was taken in the mid-1890s, and many of the men have been identified. Among these are William and Quartz Sparks (lower right with children) and two of the Sparks children, Quartz Sparks Jr. (left) and Allie (right). (Courtesy MRVM.)

CALICO CONSUMED.

A Disastrous Fire in a Promising Mining Camp.

The Postoffice, Numerous Mercantile Estab
lishments and Saloons Destroyed—
Loss about $25,000—Particulars
of the Conflagration.

On last Sunday at 12 M. a coal-oil stove exploded in Cline's restaurant, over Davis's drug store, and the whole building was immediately wrapped in flames. The fire quickly spread to Ackerman's saloon adjoining, and then destroyed in succession another saloon, the old drug store building, J. W. Miller's mercantile establishment, the postoffice, its entire contents, and the Justice of the Peace's office, the store of Soule & Tracy, general merchants, Carey's butcher shop, a jewelry store, a news depot, the new hotel of G. R. Stephens, a restaurant and barroom, James Brothers mercantile establishment, and on the other side of the street a tinshop, a photograph gallery and the Phelps building. The total loss is estimated at about $25,000. James Bros. loss is about $6000; insurance $2500. J. W. Miller's loss, $5000; insurance about $1000. Stephens' Hotel, $3000; Soule & Tracy, $6000 to $7000. There is no water in the town available for checking fires, and the consequence was that the citizens were powerless. A high wind was blowing at the time, and the only wonder is that the whole town was not consumed. The loss falls heavily on the merchants most of whom have had a hard struggle to build up a business, but no one is discouraged, and the town will rapidly be rebuilt. The news of the conflagration reached the city yesterday morning, and the above facts were obtained from two Calico citizens present at the fire.

CALICO CONSUMED. Calico has experienced four noteworthy fires: the first is described in this *Los Angeles Times* article from June 12, 1883, the second occurred December 3, 1884, the third on September 5, 1887, and the last on July 24, 2001. With the exception of the 1884 fire, which destroyed a single miner's cabin and took the life of pioneer resident Tom Leonard, each of the fires destroyed sizeable parts of the town. (Courtesy *Los Angeles Times*.)

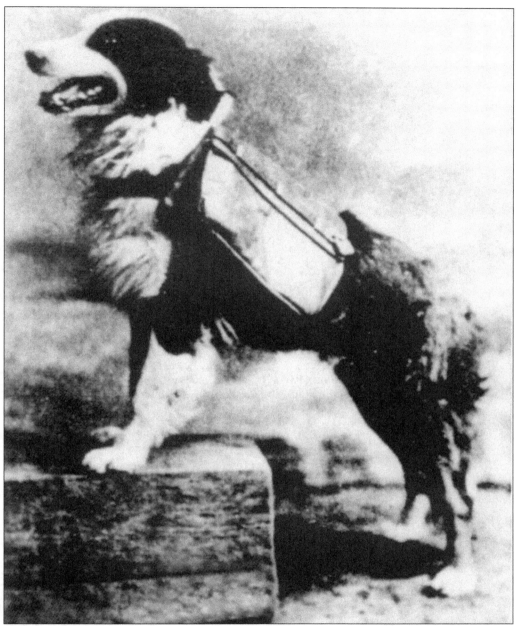

Calico Dorsey, 1883–1886. Calico Dorsey (first called Jack) was a black-and-white collie owned by Postmaster Stacy's brother, who owned a store in Bismark (East Calico). Between 1883 and 1886, the dog carried messages three times a week along a mile-and-a-half-long rugged trail between Calico and Bismark in little saddlebags strapped to his back. According to a newspaper article from February 1886, Dorsey was given to W.W. Stow, owner of the Bismark Mine, and moved to a new home in San Francisco. In 1972, Kenny Rogers revived the legend of Calico Dorsey in a song titled *Dorsey, the Mail Carrying Dog*, one of several tracks from his album *The Ballad of Calico*. In 2010, the story reemerged in a children's book written by Susan Lendroth. While a work of fiction, the book is based on facts found in Calico's history. (Courtesy MRVM.)

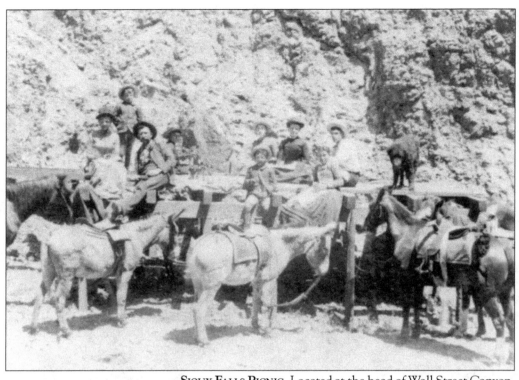

Sioux Falls Picnic. Located at the head of Wall Street Canyon, Sioux (Sue) Falls was a popular recreation area for the residents of Calico and local mines. Enjoying a picnic in this 1885 photograph are the Olivier and Rickert families. From left to right are Mrs. Rickert, Walter Oliver (boy standing), Mr. Rickert, Emma Oliver Connell, Maud Townsend, Remi Olivier (boy seated in front), Mrs. Olivier, Eugenia Olivier Dowd (girl seated in front), and Charles Rickert. (Courtesy OCA.)

M.H. Ball. With his partner H.L. Drew, Ball owned and operated H.L. Drew & Company, which supplied freight teams to the Calico area during the mid-1880s. (Courtesy MRVM.)

LENA LEVAN RILEY, 1892. Lena LeVan Riley was the daughter of William H.H. LeVan. The wealthy mining family owned the LeVan Rooming House in Calico, which burned in the fire of September 1887. As the story is told, when the rooming house started to burn, LeVan escaped carrying her pillow and bedding under one arm and a tame duck under the other. (Courtesy MRVM.)

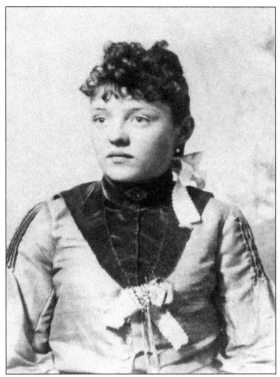

FRANK DENNING. Frank Denning was a miner and owner of the St. Louis Mine near Sioux Falls. Denning also owned property at Paradise Springs and was manager of a group of mines on the far side of Wall Street Canyon. The group, which included the California, Nevada, Washington, Idaho, New Mexico, Colorado, and Wyoming claims, was owned by Calico resident Rose L. Burcham. (Courtesy MRVM.)

ANDREW J. LASWELL, 1886. Along with John McBride and Lars Silva (Silver), Andrew Laswell, shown here at age 45, discovered the Sue (Sioux) Mine in April 1883. Laswell's home was on the west side of south Main Street; the mine was found above Sioux Falls, later a popular recreational area for Calico's miners and residents. (Courtesy MRVM.)

EUGENIA STEVENS, 1885. Eugenia Stevens was the daughter of Hugh Stevens, discoverer of the borax deposits, Calico store owner, and constable in 1885. Eugenia's mother ran a boardinghouse. Various histories imply that the Stevens' pet goat may have been responsible for the disastrous fire of September 1887 after being startled by its reflection in Eugenia's mirror and knocking over a coal-oil lamp. In 1891, Eugenia married Lewis E. Porter—Lucy Lane made her wedding dress. (Courtesy MRVM.)

JUSTICE OF THE PEACE. Col. Lewis Wallace Greenwell was a Calico mining capitalist and justice of the peace. He also served as a bookkeeper for John Lane between 1893 and 1894. Greenwell was educated at West Point Military Academy and first appears in the Calico Directories in 1888. An article in the *Barstow Printer* from May 1938 describes Greenwell as "a long-whiskered, finely educated cynic, hard to put one over on." (Courtesy MRVM.)

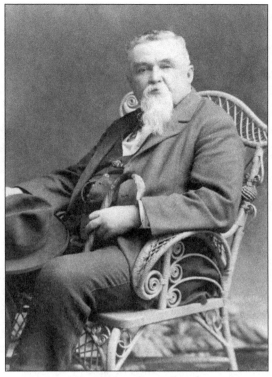

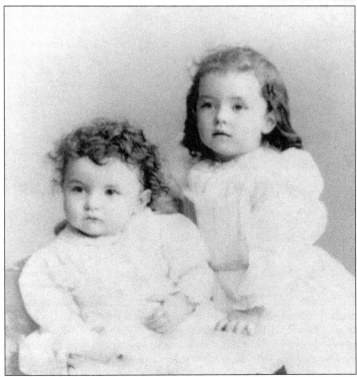

BRUCE AND EVA COCHRAN, 1885. Bruce and Eva Cochran were the children of Mrs. William Cochran, who ran a boardinghouse at the head of Occidental Canyon. In 1888, a diphtheria epidemic swept through Calico killing several of the town's children. Among them were Bruce and Eva, shown here at ages three and five. The children are buried in the Calico cemetery. (Courtesy MRVM.)

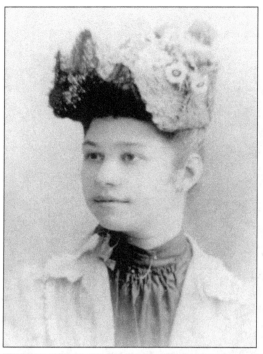

VIRGINIA ISABEL MERRITT (MOORE). At age 20, Virginia Merritt was the 1891–1892 Calico schoolteacher. Merritt was paid $80 per month and had an average class size of 29. As a refined, well-educated woman, Merritt was not inclined to marry a miner; however, after leaving Calico, she married smooth-talking Franklin Walton Moore II, foreman of the Red Cloud Mine. (Courtesy MRVM.)

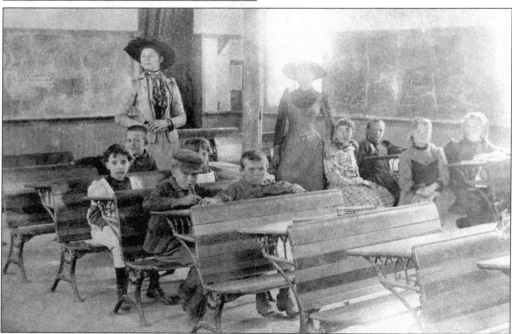

LEARNING THEIR ABCs. Although the average class size in 1891 was 29, on this day, Miss Virginia Merritt (standing left) and her assistant Fannie Lefurgey (standing right) have nine students learning their ABCs. As was the custom of the time, female teachers always wore a hat and usually gloves in the classroom. The two boys at the left front desk are identified as Bert Hodge (left) and Joe Goodwin (right). (Courtesy OCA.)

FRANK W. MOORE II.
Franklin Walton Moore II (1861–1909) was a mining engineer at Calico during the early 1890s; he supervised operations at various mines, most prominently the Red Cloud. According to his great grandson, although he was a supervisor, "he was not afraid of putting his own back in the work and was greatly respected for it." While at Calico, Moore met Virginia Isabel Merritt, schoolteacher in 1891–1892, and after moving to Los Angeles in 1895, they married. Moore soon formed his own mining consulting firm, and they had six children, including Frank W. Moore III, who died as an infant, and Frank W. Moore IV, from whom the modern family is descended. The business card Moore used while he worked in Calico is shown below. (Both, courtesy Frank W. Moore VI.)

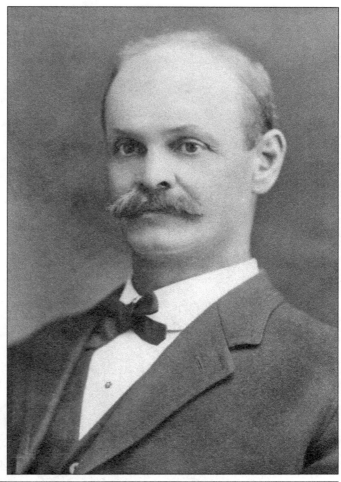

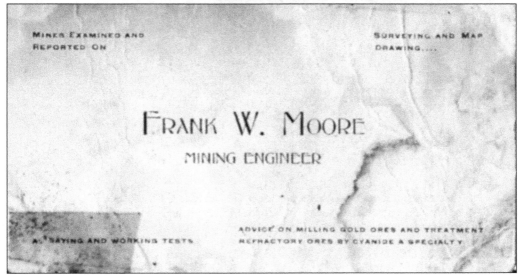

MINES EXAMINED AND
REPORTED ON

SURVEYING AND MAP
DRAWING....

FRANK W. MOORE

MINING ENGINEER

ASSAYING AND WORKING TESTS

ADVICE ON MILLING GOLD ORES AND TREATMENT
REFRACTORY ORES BY CYANIDE A SPECIALTY

CHARLES H. WOODS. Charles H. Woods was the Calico schoolteacher between 1888 and 1890. About 40 students were enrolled in the Calico School District during those two years, and the school year was eight months long. (Courtesy MRVM.)

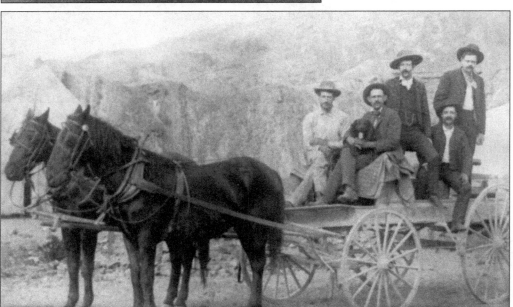

BOB PUELZ. The spring wagon and team in this late-1880s image belong to Robert "Bob" Puelz. A Calico miner originally from Iowa, Puelz is seen in the wagon with other miners who are not identified; Puelz is seated in the front holding his dog. The team and wagon, stopped in this photograph in Wall Street Canyon by a miner's tent, were apparently used in an "Irish Wake," but the details of that event are not known. (Courtesy MRVM.)

CALICO PRINT NEWSPAPER, 1886.
The *Calico Print* was Calico's
newspaper. The paper was edited by
John Gideon Overshiner between
July 1882 and September 1887.
In the 1930s, the newspaper was
revived by Grail Fuller and Lucille
Coke as a monthly tabloid. The
newer version reprinted articles
from the original paper, but also
provided timely articles for visitors
to Calico. (Courtesy MRVM.)

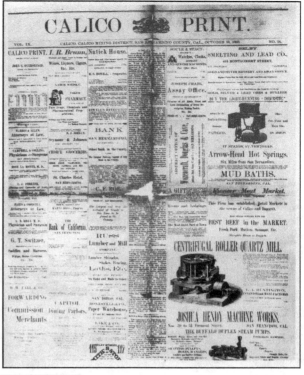

MRS. ALBERT ROLAND. Albert P.
Roland was a mining broker from Los
Angeles. In what has been reported
as the last and one of only a few
gunfights in Calico, Roland was shot
and killed in 1896 after a dispute
over a card game at the Dickerson
and Mosely Saloon. Edward
Scollard, the killer, was convicted
and sentenced to seven years at San
Quentin prison. This studio portrait
of Mrs. Roland was taken around
the early 1890s. (Courtesy MRVM.)

BAHTEN BROTHERS, 1880S. The Bahten brothers immigrated to the United States from Germany in the late 1860s; each was either a mining engineer or millwright. The 1870 US Census shows the four men living in Kern County, California. In that year, Henry was 42, Diedrick 33, John 28, and Gottfried 25. In the early 1880s, the four men moved to the Daggett/Calico area and continued mining. They also owned the Bahten Brothers Meat Market in Daggett, a slaughterhouse, icehouse, and a lodging house in Calico, which was destroyed in the 1887 fire. Diedrick was supervisor of the Waterloo Mill and on the board of directors of the Calico Water-Works Company in 1885. Although the photograph is unmarked, Gottfried's great granddaughter, Sydney Mozingo, believes they are, from left to right, Diedrick, John, Gottfried, and Henry. The image is the only one known of the four brothers together. (Courtesy Sydney Mozingo.)

Two

MILLION DOLLAR DIRT

THE BORAX EXPERIENCE

"BORAX" SMITH. Francis Marion "Borax" Smith (1846–1931) arrived in California in 1867 with $155 in his pocket. Having seen a borax operation in Nevada, he recognized the potential of the deposits in Mule Canyon and established the Pacific Coast Borax Company at Borate. Seen here in 1907, the "Borax King" is best known for developing and aggressively marketing the famous 20 Mule Team Borax trademark and products. (Courtesy MRVM.)

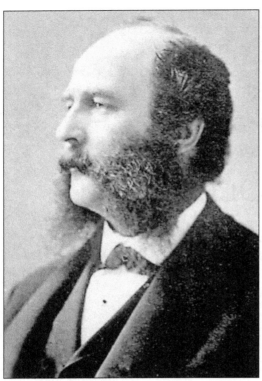

WILLIAM TELL COLEMAN. Before becoming an associate of Borax Smith, William T. Coleman had already been in the borax business for more than 15 years. In some endeavors, Smith and Coleman were competitors, but they always remained friends. In the Calico operations, Smith was the borax producer and Coleman was the financier and distributor. (Courtesy MRVM.)

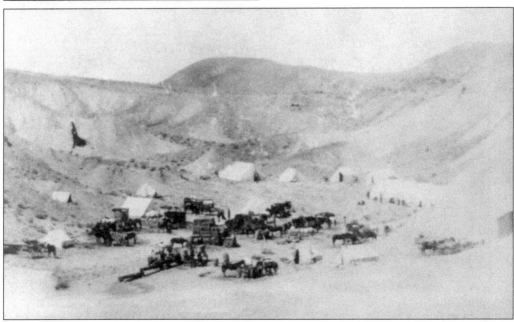

RAILROAD WORK CAMP. Between 1897 and 1898, Borax Smith had a narrow gauge railroad line constructed between Borate and Daggett to speed up operations and reduce the costs of hauling ore by mule train. While the track was being laid, work crews used this tent-style work camp in Happy Hollow. (Courtesy MRVM.)

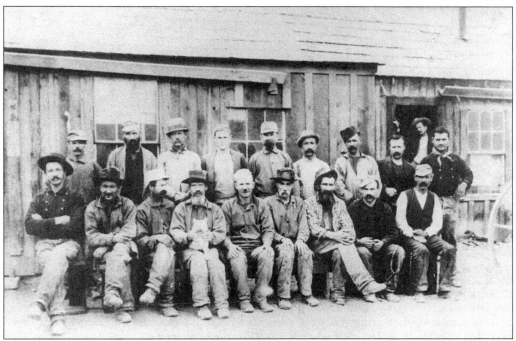

BORATE. Workers at the borax mines in Borate lived in tents, caves, or frame bunkhouses, like the one shown above. Posing with his crew, Supt. John Washington Perry is standing in the doorway. Borate had a dining hall, company store, reading room, and a small cabin each for the storekeeper and mine foreman. There was also a large home for mine owner Borax Smith at the head of the canyon (below). Because of fierce winds, Smith's house had to be tethered at all four corners with steel cables. When the town was abandoned, Smith's furnishings were loaded onto the forward car behind the locomotive for transport to Death Valley. Sparks from the stack ignited the goods, and by the time the train could stop, Smith's possessions had been almost totally destroyed. (Both, courtesy MRVM.)

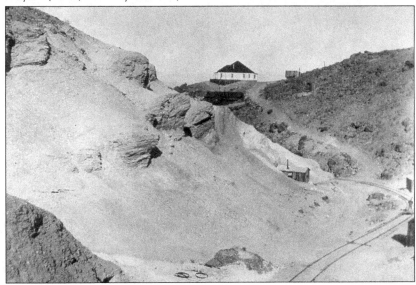

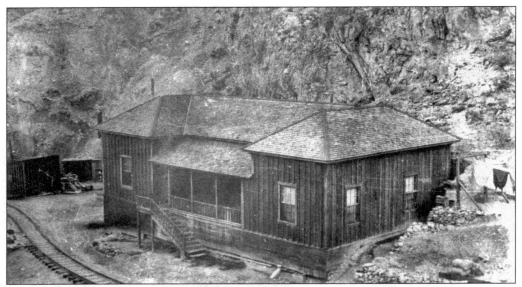

BORATE SUPERINTENDENT'S RESIDENCE. Between 1899 and 1907, the William "Billy" Smitheram family lived in this dwelling in upper Borate Canyon. Smitheram moved to Borate from Borax Smith's operations in Nevada and was the operating superintendent who followed J.W.S. Perry. Perry has also been credited with designing the 20-mule-team wagons. (Courtesy MRVM.)

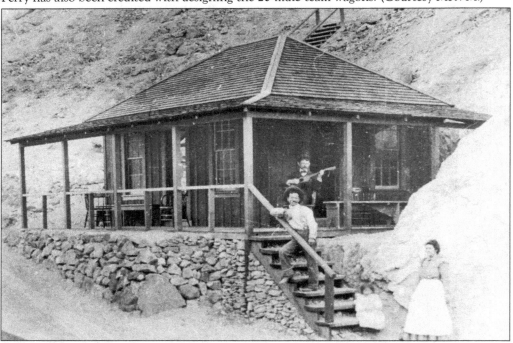

BORATE READING ROOM. Isolated mining communities almost always had areas set aside for recreation and entertainment. Borax Smith had this small building constructed as a reading room, but it was most often used for social gatherings and card games. With the exception of Smith's hilltop residence that was painted white, all of Borate's buildings were of this design. (Courtesy MRVM.)

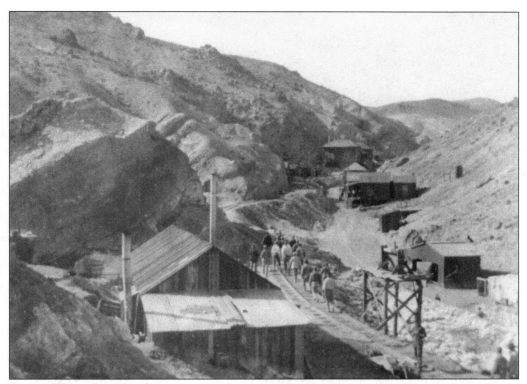

OFF TO WORK. By 1898, there were numerous wood industrial buildings and dwellings at Borate, and the narrow gauge railroad was complete. In this image, miners are walking to work along the track. The residence at the upper center was that of the Fred Corkill family. Corkill was the senior mining engineer and managed production for Borax Smith at both Borate and Marion. (Courtesy MRVM.)

JACOB KEIFER. "Jake" Keifer worked as a foreman for the Pacific Coast Borax Company in Borate during the mid-1890s. At this time, many of the company's employees were transitioned from Borax Smith's operations in Teel's Marsh, Nevada, to the newly discovered Calico borax mines. (Courtesy MRVM.)

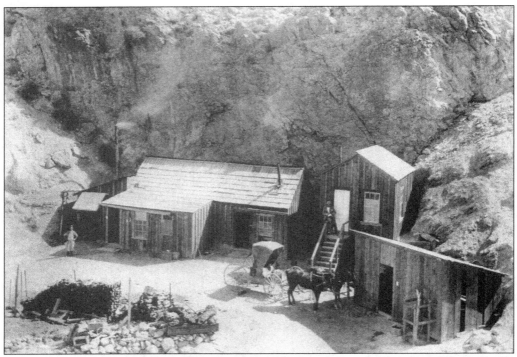

BORATE BOARDINGHOUSE. Shown here in 1891 are the Borate Boardinghouse and Cook Shack. A stable is at far right, and a Chinese cook is standing at the far left. At the top of the steps in front of the small cabin is John Washington Perry, the first Borate superintendent of operations. (Courtesy MRVM.)

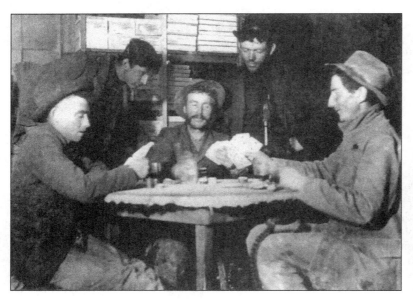

MINERS AT PLAY. Five Borate miners are enjoying a game of cards in the Borate reading room. Standing at the right is William Washington "Wash" Cahill. Clarence "Lew" Rasor, who later became chief engineer at the American Borax Company, is seated at the far left. (Courtesy MRVM.)

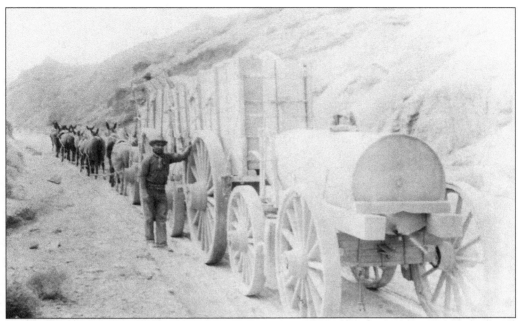

BORAX HAUL ROUTE. A Pacific Coast Borax Company 14-mule-team wagon train is seen resting in Mule Canyon along the borax haul route in this 1894 image. The teamster is Charlie White and the swamper standing by the wheel is Ed Pitcher. The configuration of this wagon train is typical of mule teams, with two large ore wagons and a water wagon at the rear. (Courtesy MRVM.)

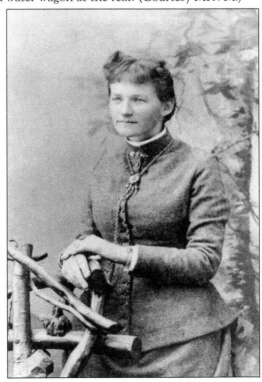

LUCY E. MCCUISTAN (WHITE), 1880s. Lucy McCuistan was the wife of R.T. McCuistan, who was a Calico teamster between 1885 and 1889. After her husband died, she married Charles White, a teamster for the Pacific Coast Borax Company. Lucy reportedly died a "victim of the elements"—the desert heat. (Courtesy MRVM.)

51

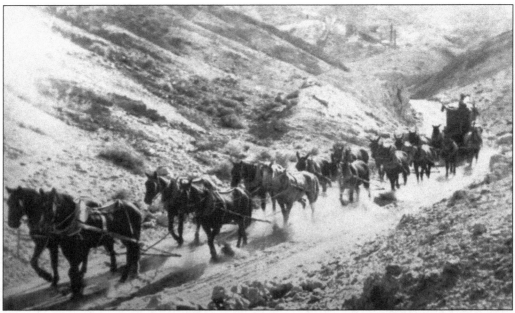

ROARING DOWN MULE CANYON. This photograph from the mid-1880s depicts a Pacific Coast Borax Company team roaring down Mule Canyon. The tall stacks of the Borate Mill are in the center background. Teamster Charlie White and swamper Ed Pitcher often worked with one another and are seen together in similar images from this period. (Courtesy MRVM.)

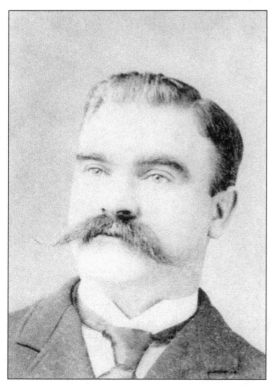

EDWARD L. PITCHER, C. 1900. Ed Pitcher was a 20-mule-team swamper and, after an apprenticeship, a teamster. With his partners Frank Tilton or Charles White, Pitcher hauled borax from Borate to Daggett. When the 20-mule teams were replaced by the railroad, Pitcher was elected constable of Barstow and with his wife, Ella Connors Pitcher, purchased and operated the Inez Hotel in Barstow. (Courtesy MRVM.)

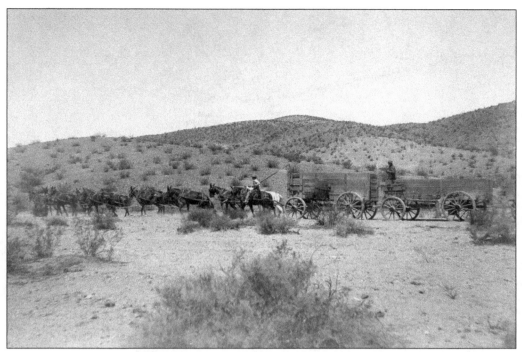

HAULING BORAX NEAR BORATE. This 14-mule team is hauling three ore and supply wagons near Borate in 1906. The young teamsters are Harry C. Ambrose and Tom Redormin, both of whom were about 20 years old at the time. (Courtesy MRVM.)

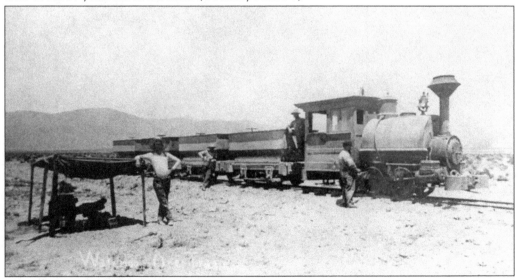

WATERLOO PUFFERBILLY. This "pufferbilly"—a slang term for small steam engines used around the turn of the 20th century—is hauling ore cars between the Waterloo Mine and Calico. Each ore car could carry eight tons of ore. The narrow gauge railroad connecting Daggett, the Waterloo Mine, and Calico was completed in 1898 and was financed by Borax Smith. Shown during a work break, the engine is having its wheels oiled by the railroad worker near the front. (Courtesy MRVM.)

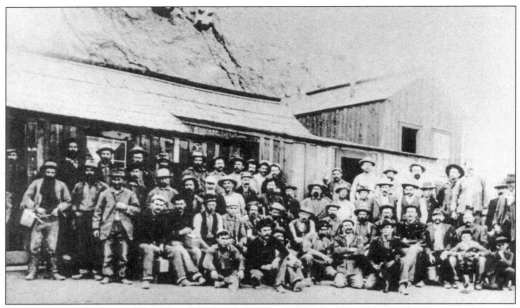

FULL CREW AT BORATE. Posing in front of the miners' boardinghouse in 1892 is Borate's full work crew. Standing at the far right (with hat) is Hugh Stevens, the Calico storekeeper who first found the borax deposits in 1882. (Courtesy MRVM.)

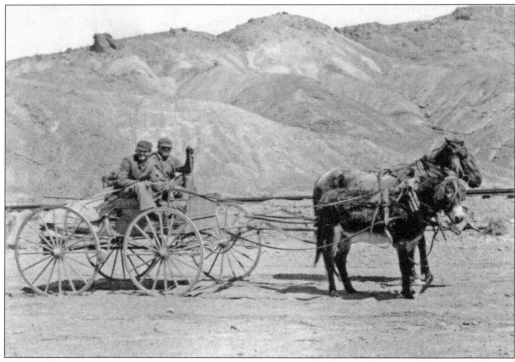

BORATE PROSPECTORS. In this image from 1901, two unidentified miners are hauling supplies in their buckboard near Borate. The track of the narrow gauge Borate & Daggett Railroad is just behind the wagon. (Courtesy US Geological Survey.)

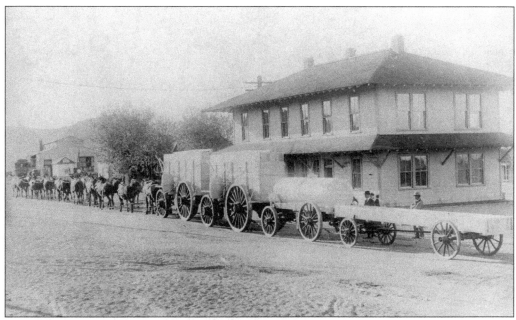

A 20-Mule Team in Daggett. The c. 1904 photograph above shows a 20-mule team waiting by the Daggett depot. Although borax was being produced from the mines at Borate, a sign painted on the second wagon indicates that this wagon train originated in Death Valley. The flat rear wagon reads, "20 Mule Team Borax Soap Caps Clean Things Clean—It's the Borax in the Soap that Does All the Work." Below is an 1894 image of "Old Dinah" at work in Borate. Dinah, a steam tractor, was supposed to be an economical replacement for the 20-mule teams, but the maintenance costs were so high that the mules were soon returned to service until ultimately replaced by a narrow gauge railroad. Harold Grey is the engineer behind the wheel. (Above, courtesy OCA; below, courtesy Feldheym.)

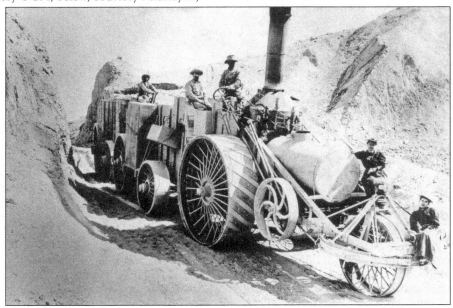

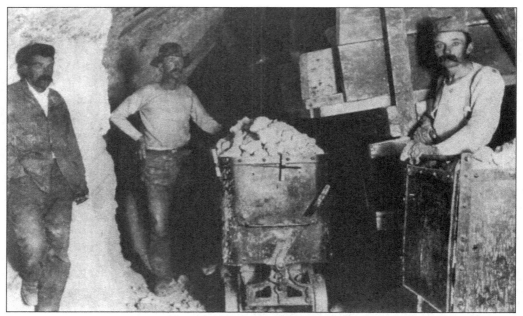

LOADING COLEMANITE. The unidentified miners in this early-1900s image are loading colemanite—the form of borax found at Borate—into small mine ore cars. From this point, the ore was taken by narrow gauge railroad to the Marion roaster for processing. (Courtesy MRVM.)

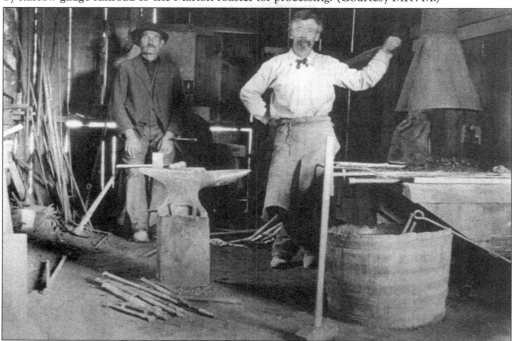

BLACKSMITH SHOP. In 1895, William J. "Bill" Boreham (right) was the Borate blacksmith. Census records indicate that Boreham was also the 1900 and 1910 census enumerator for Belleville Township, which included Calico, Borate, and Marion. The identity of the other miner is not verified, but is probably Chris Weidman, the blacksmith's helper. (Courtesy MRVM.)

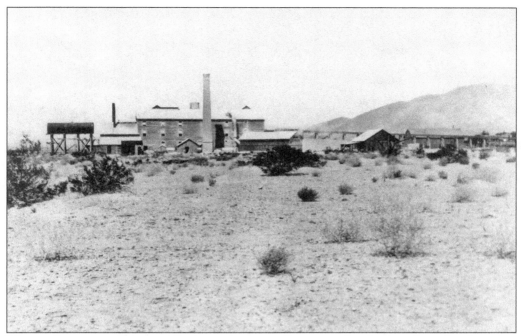

MARION PROCESSING FACILITY. The borax deposits at Borate were harder than those found at other mines. Known as colemanite after William Tell Coleman, this type of borax required a special facility for processing. The mill to support Borate was completed at Marion in 1898 on the east end of Calico Dry Lake and was known as the Marion Roaster. (Courtesy MRVM.)

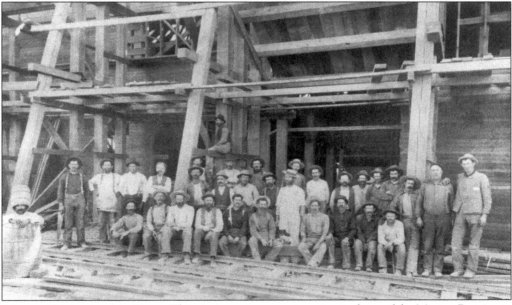

MARION CONSTRUCTION CREW. This construction crew is posing in front of the Marion Roaster in 1907. The narrow gauge track of the Borate & Daggett Railroad that linked Borate with Marion is in the foreground. In a display of humor, the miner at the far left is sitting in a barrel with a smaller barrel on his head. (Courtesy MRVM.)

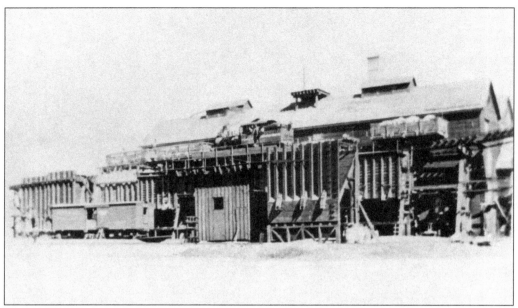

MARION ROASTING PROCESS. The Marion Roaster and Calciner Plant was an innovative approach to processing borax. The plant used a special furnace that roasted the ore at 1,200 degrees. A process called calcining removed water in the ore and shattered it into a fine powder. The powder was screened to remove impurities, shipped to Alameda, California, for purification, and packaged for commercial and home use. (Courtesy Feldheym.)

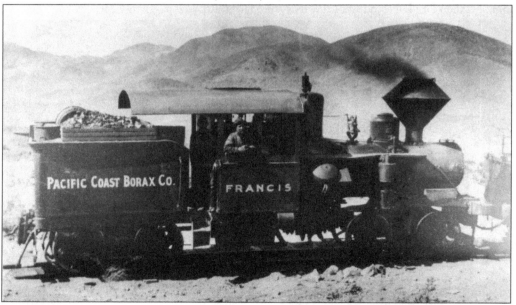

FRANCIS PUFFERBILLY. After 1898, borax was hauled between Borate and Marion along the Borate & Daggett Railroad. Given the steep terrain, completion of the railroad was considered an engineering marvel. The Francis and the Marion, two Heisler locomotives powered by coal, made daily runs between Borate and Marion. A third engine "puffed" across the last leg between Marion and Daggett. The engineer in this 1907 image is Jerome Connelly. (Courtesy MRVM.)

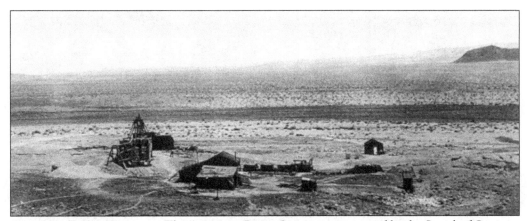

AMERICAN BORAX COMPANY. The American Borax Company was owned by the Standard Sanitary Ware Company and was founded in 1900. This company operated the Columbia Mine near Lead Mountain, which mined a low grade of underground borax shale. The company was a competitor of Borax Smith's operations. After completion of the Tonopah & Tidewater Railway, the American Borax Company moved its operations closer to the Pacific coast. (Courtesy MRVM.)

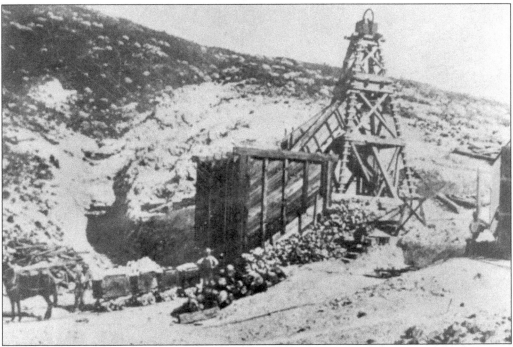

COLUMBIA MINE SHAFT. In this image from the early 1900s, miners at the Columbia mine shaft are loading ore into four small, mule-drawn ore carts. Ores brought up from the shaft and headframe to the right were emptied into the ore chute and bin, which then filled the carts. (Courtesy MRVM.)

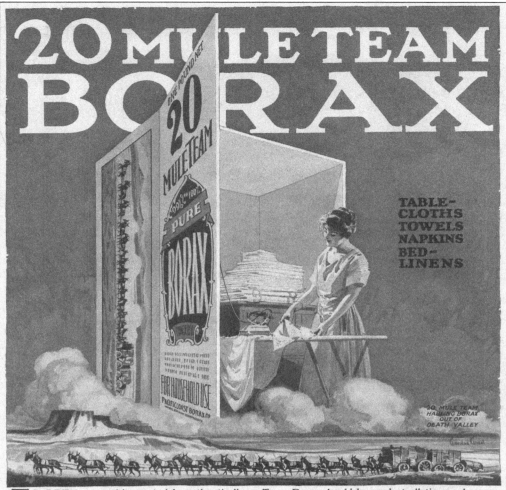

20 MULE TEAM BORAX

**TABLE-CLOTHS
TOWELS
NAPKINS
BED-LINENS**

*20 MULE TEAM
HAULING BORAX
OUT OF
DEATH VALLEY*

TO GET heavy white materials antiseptically clean, actually white and fresh smelling, 20 Mule Team Borax is absolutely necessary in their washing, no matter what kind of soap is used.

20 Mule Team Borax is a solvent and a protector of dainty colors and delicate fabrics in the washing. It increases the cleansing action of any soap and acts as a water softener. It prevents colors from fading. The safest rule for your laundry is that 20 Mule Team Borax should be used at all times wherever soap is used.

There are more than a hundred essential household uses for 20 Mule Team Borax and it is good for everything it touches. 20 Mule Team Borax is in all clean kitchens. Is it in yours? At all grocers, department stores and druggists. Send for Magic Crystal Booklet.

PACIFIC COAST BORAX COMPANY
100 William Street New York City

NATURES GREATEST CLEANSER

MILLION DOLLAR DIRT. An article in the *Los Angeles Times* from July 1932 called borax the "Million Dollar Dirt." The 20 Mule Team brand name was developed and aggressively marketed by Borax Smith in the early 1900s and is still manufactured today. As shown in this typical advertisement from 1923, the product is used for more than 100 purposes. As a flux, borax is used in glazing pottery and is a component of glass ovenware, colored enamel kitchen utensils, and glazed ceramic tiles. In its boric acid form, it is used in toothpaste, deodorant, and cold cream and to make glue. Borax is also used by manufacturers of textiles to make straw and felt hats, to tan leather, and in soldering and welding operations. Borax is best known as a cleaning product and water softener and is used "to make dance floors speedy." (Author's personal collection.)

60

Three

NOBODY HOME

THE DESERTED DECADES

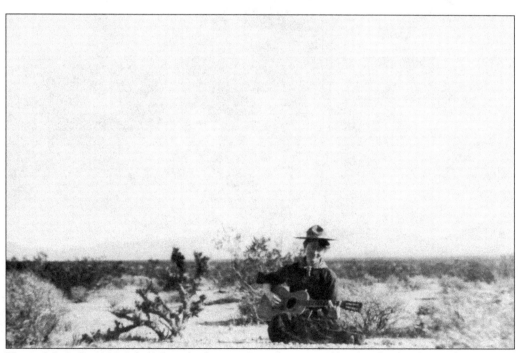

HELEN MUIR. In 1908, John Muir, the famous naturalist, moved his daughter Helen to the Daggett/Calico area for her health. In 1909, Helen married Buel Funk, son of a partner in the Van Dyke Ranch, and they raised four sons in the area. In this image from about 1910, Muir is seen playing the guitar against the backdrop of the Mojave Desert and Calico Hills. (Courtesy MRVM.)

MUIRS AND VAN DYKES. John Muir (far right) and his daughters Wanda and Helen (second from left) are shown with Dix Van Dyke (center) and his father, Judge Theodore Strong Van Dyke. John Muir fell ill with pneumonia while visiting Helen at the ranch and died on Christmas Eve 1914. This image is believed to be one of the last photographs taken of him. (Courtesy New Brunswick Theological Seminary, Gardner A. Sage Library Archives.)

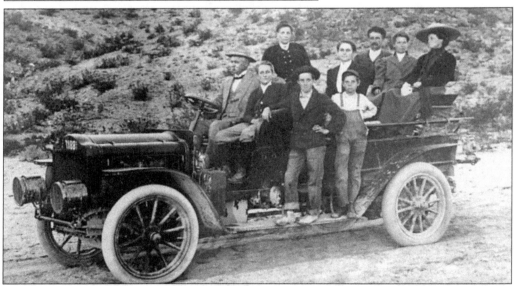

DILLINGHAMS VISIT CALICO. The Reece Dillingham family moved to Barstow in 1900. A wealthy businessman, Dillingham purchased a cabin in the San Bernardino Mountains to escape the summer heat. On their trips to and from the cabin, they often visited with the Lane family in Calico. In this 1911 image, the Dillingham family and friends are posing at Calico in their Stanley Steamer automobile. (Courtesy MRVM.)

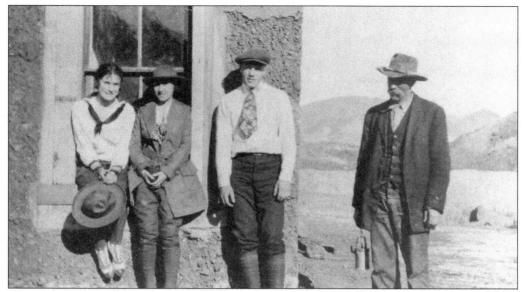

JOHN LANE AND DILLINGHAMS. During one of their many visits to Calico, the Dillinghams are seen posing with John Lane (right) next to the Lane house. With Lane in this image from the mid-1910s are, from left to right, Jean and Hilda Dillingham and Reece Dillingham Jr. (Courtesy MRVM.)

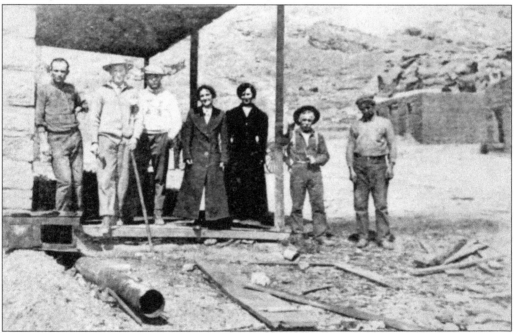

CALICO GATHERING. This group of Calico visitors is gathered in front of the abandoned Stone Front Building sometime between 1910 and 1920. The man at the far left bears a resemblance to a young Walter Knott, who frequently visited Calico during his homesteading years in Newberry Springs, but that is not confirmed. Second from left may be Reece Dillingham Sr., followed by Reece Dillingham Jr., Jean and Hilda Dillingham, and two unidentified Calico miners. (Courtesy MRVM.)

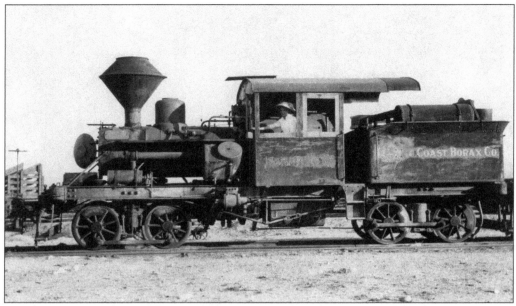

MARY BEAL. In 1900, Mary Beal (1878–1964) moved with her family from Illinois to Riverside, California. After contracting pneumonia, Beal moved to Daggett and lived at the Dix Van Dyke Ranch where she spent decades cataloging and photographing Mojave Desert plants and features. In this c. 1910 photograph, Beal is posing in the cab of a Pacific Coast Borax Company narrow gauge ore train parked at the old Daggett railroad shop. (Courtesy OCA.)

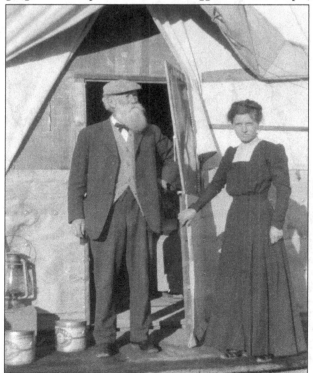

BURROUGHS'S VISIT TO CALICO. While in Riverside, Mary Beal assisted John Burroughs, the famous naturalist and author, with his research. The two became friends, and that friendship was the catalyst for Beal's lifelong interest in the botany of the Mojave Desert. Burroughs and Beal are pictured in 1911 at her tent home on the Van Dyke Ranch. (Courtesy Mojave Desert Archives, Dennis Casebier.)

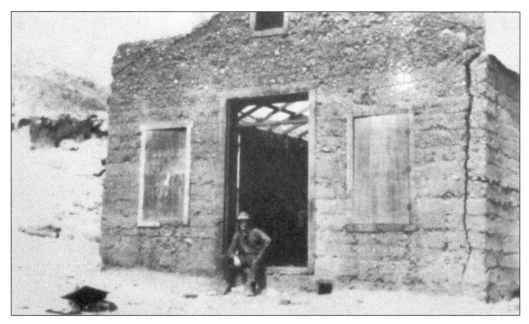

NATURALISTS AT CALICO. During John Burroughs's visit with Mary Beal in 1911, they took an excursion to Calico. To shelter from a passing shower, they stabled their horses in the ruins of Rhea's drugstore (above) and picnicked in the Calico dance hall with Raymond Clifford (above and below, right), another resident of the Van Dyke Ranch who accompanied them on their outing. Captivated by the area, Burroughs vowed to return but never did; Beal intended to stay in the area for about 18 months but never left. An avid photographer, Beal is believed to have taken both of these images. (Above, courtesy MRVM; below, courtesy Mojave Desert Archives, Dennis Casebier.)

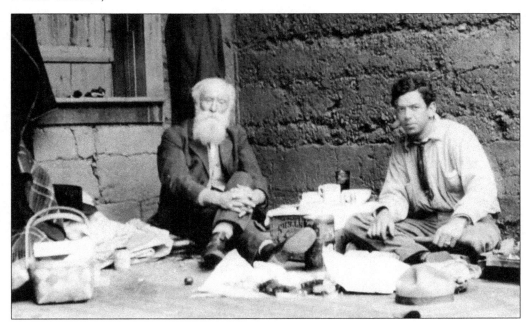

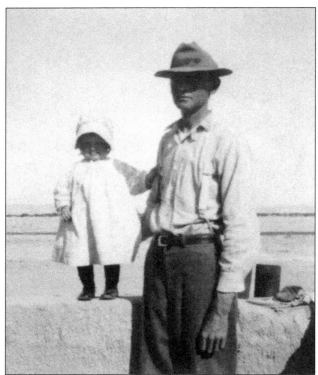

KNOTTS HOMESTEADING. In 1913, Walter and Cordelia Knott and their new baby Virginia moved to a small adobe home five miles from Newberry Springs. Knott's hope was to improve the 160-acre parcel by homesteading for three years, after which the land would be his free and clear. Unable to establish a water well sufficient to support the home, farm animals, and crops, he soon turned to odd jobs to support his growing family. He made adobe bricks for other homesteaders and later (in 1915) worked as a carpenter in Calico helping to rebuild one of the mills. With their farming hopes dashed, the Knotts finally left Newberry in 1917, the same year their third child, Toni, was born. In these images taken at Newberry about 1914 are Walter with Virginia and Cordelia with Virginia and Russell. (Both, courtesy OCA.)

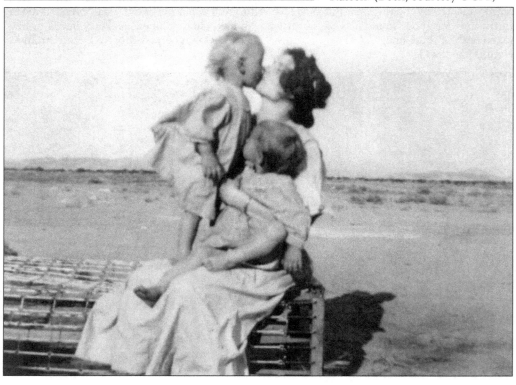

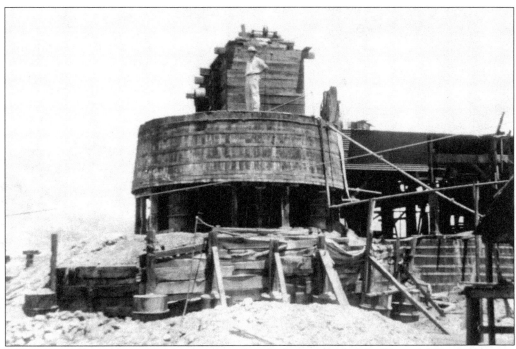

CALICO CYANIDE PLANTS. The large redwood tank above is part of the Knute Millett Processing Plant, which was located between Mule and Odessa Canyons. The image was taken during a period in Calico's history when old mine tailings were processed with cyanide to extract residual silver. The man standing on top of the tank is believed to be a young Walter Knott. While homesteading with his family in Newberry Springs, Knott worked as a carpenter building the redwood tanks. The image below is from about 1920. This cyanide plant was owned by David Gimmell, his brother, and John Jackson. The plant recovered silver from the tailings of Oriental Mine No. 2 and the Red Cloud group of mines. (Both, courtesy OCA.)

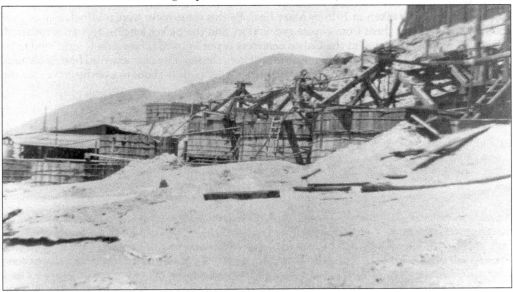

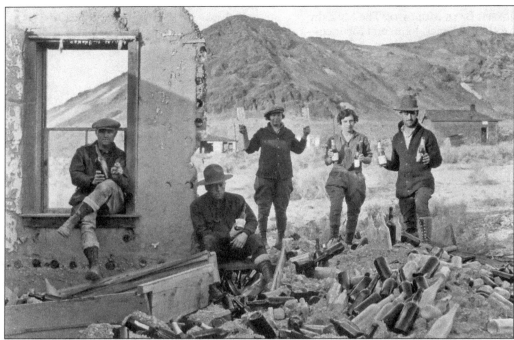

SIGHTSEEING TOUR, 1926. A group of adventurous travelers took an automobile trip between Los Angeles and Death Valley with stops at Rhyolite, Cave Springs, and Calico in 1926. The trip was chronicled in a diary with 76 captioned photographs. In these two images, the group explores one of two Rhyolite bottle houses that were used by Walter Knott as the inspiration for the bottle house at Calico. Below, the group has stopped for the night at Cave Springs (near Calico), a water and rest stop for borax wagons between 1883 and 1887. The caption notes that their "machines" are parked in the Cave Springs Corral. The small, white house in the center was built by Adrian Egbert in 1925 and sold groceries, gas, and oil to travelers until about 1939. (Both, courtesy The Bancroft Library, University of California, Berkeley.)

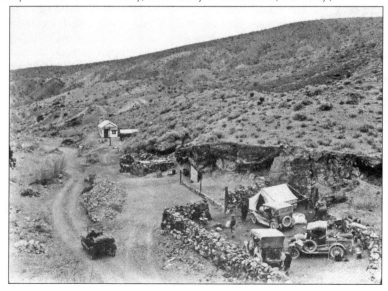

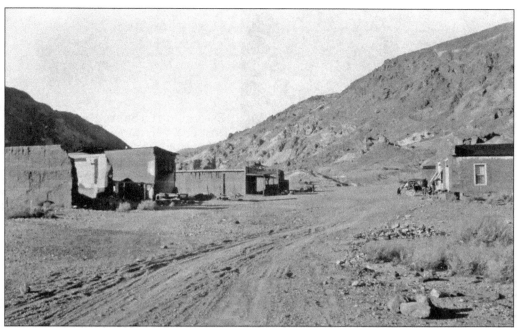

ARRIVAL AT CALICO. Continuing on their 1926 automobile tour, the intrepid sightseeing group from Los Angeles stopped at Calico on the last leg of their trip. The image above shows Calico's Main Street looking toward the north with the remnants of adobe structures lining both sides and mine tailings in the background. Below, John and Lucy Lane, the only residents of Calico at the time, are graciously posing for the visitors. In 1926, John would have been 67 years old and Lucy 52. The automobiles of the group are parked in the background by the Lane House. (Both, courtesy The Bancroft Library, University of California, Berkeley.)

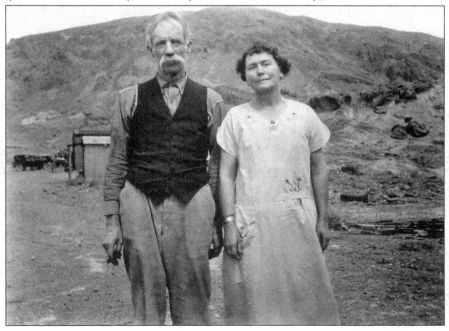

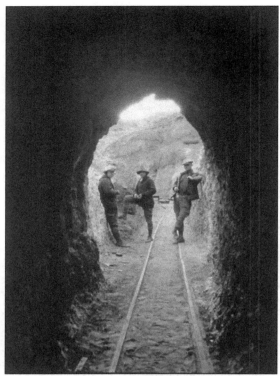

EXPLORING THE SILVER KING. After a brief visit with the Lanes, the automobile sightseeing group explored the Silver King Mine and set up camp for the night. According to the captions for these images, "here, through the courtesy of the one resident an old miner [John Lane] who provided us with carbide lamps, we inspected the mine after which we drove in the canyon below the town [Wall Street Canyon] and made camp." Shown at left at the entrance to the mine are three members of the group. They are identified from other photographs in the collection as Mrs. Perelet (left), Miss Muth (center), and Mr. Abbott. (Both, courtesy The Bancroft Library, University of California, Berkeley.)

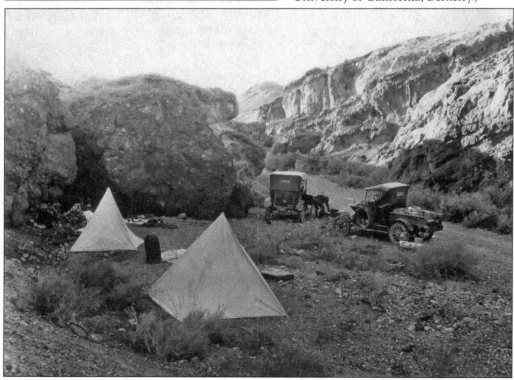

FAREWELL TO CALICO. On the last morning before their return home, the automobile touring group had a pancake breakfast prepared by Miss Muth at their Wall Street Canyon campsite. From the various items shown at right, Miss Muth was using Mill's Brothers coffee, Ben Hur Pepper, Van Camp's canned potatoes, and Log Cabin Syrup from its distinctive cabin-style tin. The remains of a single eggshell are perched on a rock just over her shoulder. Below, the group is leaving Wall Street Canyon on the last leg of their trip. The ruins of Calico's adobe buildings are above the canyon on the left. (Both, courtesy The Bancroft Library, University of California, Berkeley.)

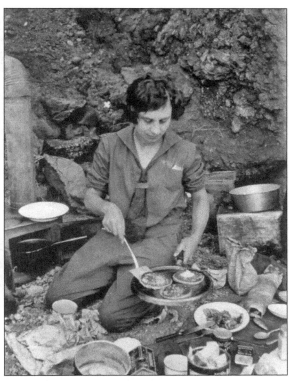

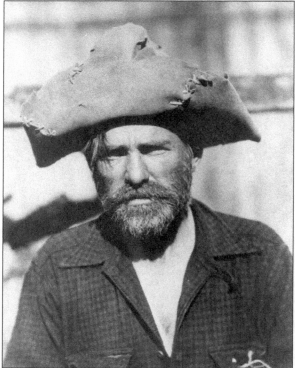

ZENDA MINING COMPANY. With the exception of their home, John and Lucy Lane transferred options on the Calico townsite and their mining sites to the Zenda Gold Mining Company in 1926. In 1928, the company sank shafts for the Calico-Odessa group of mines. Shown here in 1932 are two of the company's buildings when they were in use by Zenda. (Courtesy MRVM.)

EARLY CALICO DAYS. In the early 1930s, enterprising residents of Barstow, Yermo, and Daggett started the annual tradition of Old Calico Days to celebrate the history of Calico's silver mining boom. The three-day event was held in Yermo and included activities such as reenactments of the first silver discovery and burro races. Charles Mitchell, owner of Daggett's Beacon Garage, is shown here dressed for the 1935 event. (Courtesy MRVM.)

FEDERAL WRITERS' PROJECT. Created in 1935 as part of the Work Progress Administration (WPA), the Federal Writers' Project was to provide employment for historians, teachers, writers, editors, librarians, and other white-collar workers. The project operated in all states and at one point employed as many as 6,600 men and women. The most important achievement of the project was the production of encyclopedic guides that combined travel information with essays, architecture, history, and commerce. Calico was among the small communities visited by Federal Writers' Project staff. At right, the Calico project writers have arrived at Calico; below, the writers photographed Calico from the hillside above town as it looked during their visit in 1947, the last year that the project was federally funded. (Both, courtesy WPA Collection/Los Angeles Public Library.)

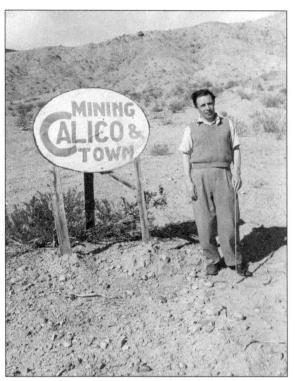

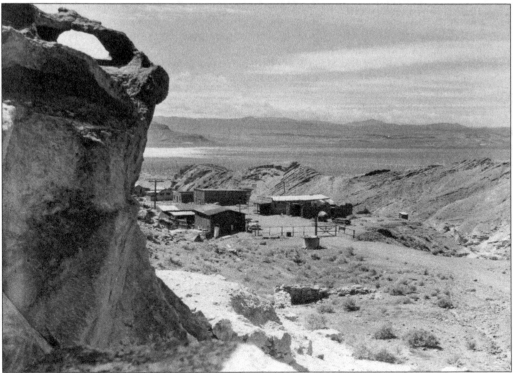

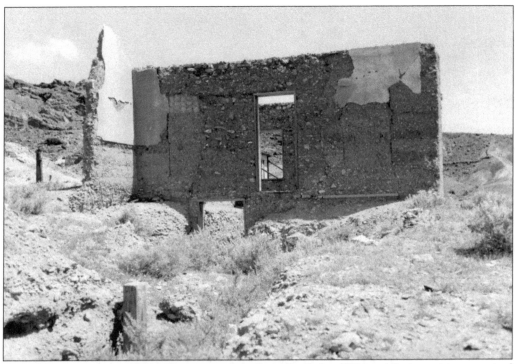

CALICO LANDSCAPE IN 1947. These two images from the Federal Writers' Project visit are typical of Calico's abandoned landscape in the 1940s. Above, the walls of a rammed-earth adobe house are seen on the hillside. Remnants of the smooth, interior finish of the building remain, and an orderly arrangement of smooth cobbles are seen in the upper-left corner—probably part of the dwelling's chimney and fireplace. From a vantage point high above the Calico townsite, the image below shows the remains of the Silver King Mine's narrow gauge tram. An abandoned, toppled ore car sits precariously among the twisted track at center. (Both, courtesy WPA Collection/Los Angeles Public Library.)

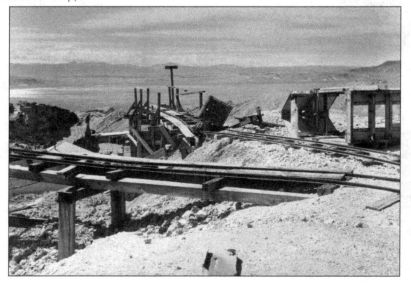

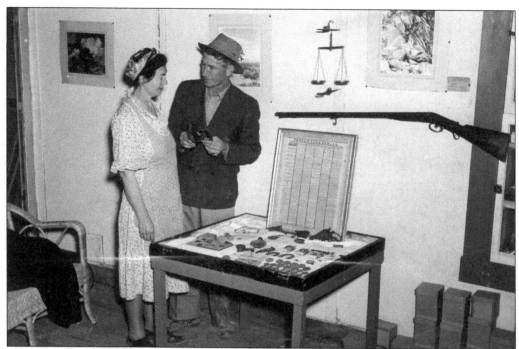

THE COKES IN CALICO. Lawrence and Lucille Coke (above) lived in Calico between 1934 and 1949. At the time of the Federal Writers' Project visit in 1947, they were noted as the only inhabitants. During their years in the town, the Cokes found and collected remains from Calico's boom years and opened a museum and rock shop (below) in the former A.R. Rhea drugstore. In the above image taken inside the museum, the Cokes are examining a Chinese laundry iron, which was heated by filling the hollow brass body with hot iron ingots. (Both, courtesy WPA Collection/ Los Angeles Public Library.)

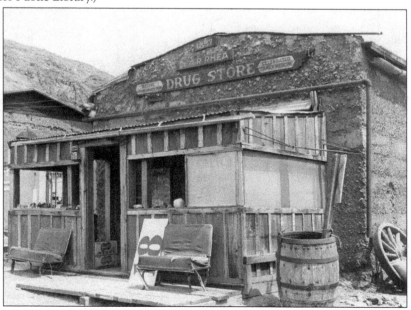

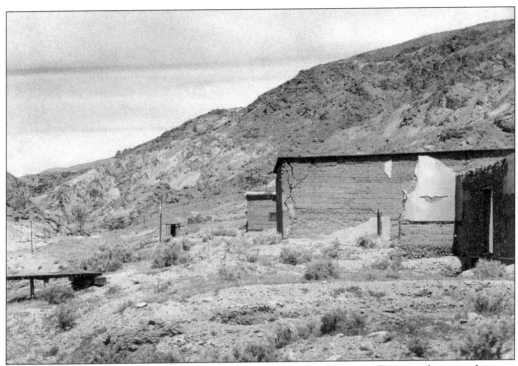

RAMMED-EARTH RUINS. As part of the mission of the Federal Writers' Project, photographs were taken to document the people, architecture, and history of the community. In these two images, the writers capture the ruins of some of Calico's abandoned buildings. Above are rear views of buildings perched on the edge of Wall Street Canyon. The ruins below are noted to be the walls of houses in Calico's Chinatown. (Both, courtesy WPA Collection/Los Angeles Public Library.)

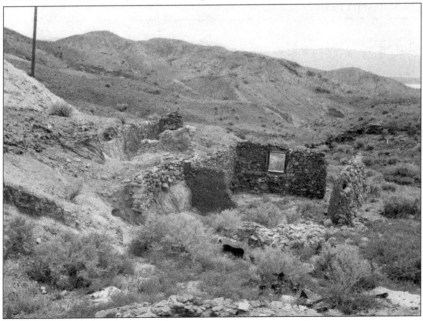

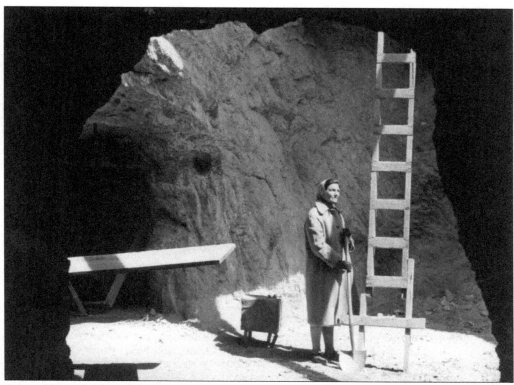

GLORY HOLE. In this image, the Federal Writers' Project staff have captured Lucille Coke at the bottom of a silver mine glory hole. The only access to the area was by the crudely built wooden ladder. (Courtesy WPA Collection/ Los Angeles Public Library.)

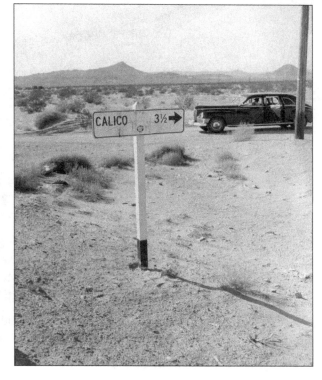

VISIT'S END. At the end of their Calico visit, the Federal Writers' Project staff paused by the road sign pointing to Calico. Their automobile, shown in the background, is a 1947 Packard Super Clipper four-door sedan. (Courtesy WPA Collection/ Los Angeles Public Library.)

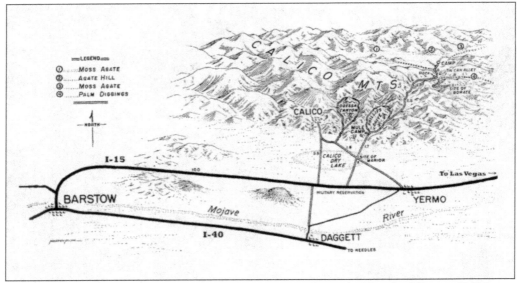

WHERE THINGS WERE. This map of the Calico area was drawn by Norton Allen in 1947 for an article in *Desert Magazine*. Allen frequently drew maps and other diagrams for the magazine, which was published between November 1937 and June 1985. The January 1948 article was a guide for rock hunters exploring the Calico area, and the above diagram shows geological areas where "pretty rocks" could be found. (Courtesy Mojave Desert Archives, Dennis Casebier.)

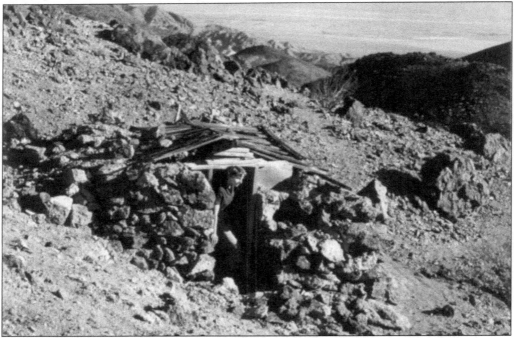

COUSIN JACK HOUSE. This photograph was taken by Harold Weight in 1950. The woman, Martha Berry, is exploring a "Cousin Jack" house, which was located near the Bismark Mine. Scattered on the steep hillsides around the town, Cousin Jack houses were little more than piles of rock and scraps of wood. (Courtesy OCA.)

Harvey Children Greetings. The two-page letter shown on this page was written to Walter Knott by the Harvey children in 1949. The letter describes the children's excitement over the future restoration of the town and mentions Lucy Lane and how she was part of Walter Knott's "real" ghost town. A photograph of the three children during a visit to Calico was enclosed with the letter and is shown on the following page. (Both, courtesy OCA.)

Dear Mr. Knott,

We read in the paper that you bought Calico, the ghost town. This made us very happy because you will make it attractive to visitors that don't know about it now.

I was born in Barstow when my mother and father lived near Calico, in Yermo. My Dad worked in Calico driving a dump truck taking silver out of the tailings at the Zenda mine and other mines nearby.

Daddy's folks homesteaded government land out in the desert near Barstow so he knows lots of true stories about Calico. That is why we are glad you will preserve its old traditions. Let us know when you have it all fixed up so we can make a trip up there to see it.

We bought a book about "Calico" at your "Ghost Town" here. My folks knew the authors of it. But

they didn't write about one of the old timers that lived in Calico. Her name is Mrs. Lane. You've probably have the story about her. But we thought you might like to have a photo of her. This was taken in 1938. We don't know if she is still living, or not. She's shoveling silver ore into sacks that she shipped to the government. We thought you'd might like the picture of your real ghost town.

Good Luck with your new project. The west will be proud of you.

Best Wishes
Gene, Wayne, and Hank Harvey
916 N. 10LA Ave.
El Monte, Calif.

P.S. Here is a piece of silver my father mined in Calico. Will you please send us a autographed photo of you?

81

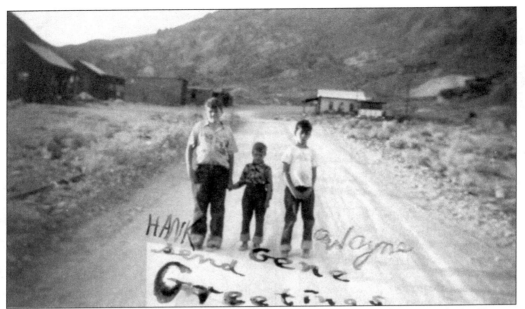

Harveys Visit Calico, 1949. Attached to a letter to Walter Knott (previous page), the Harvey children sent this photograph of their visit to Calico in 1949. The image has a perspective not seen in other historic photographs from the 1940s and identifies each boy by name—Hank, Gene, and Wayne. (Courtesy OCA.)

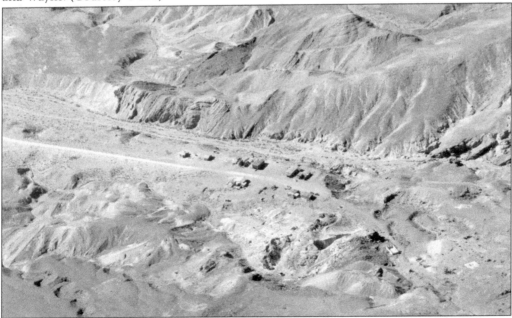

Bird's-eye View. This aerial photograph from 1949 reveals how Calico would have looked at the time Walter Knott purchased the property. The view looks toward Wall Street Canyon and was likely a reconnaissance photograph commissioned by the Knott family prior to their purchase. Paul von Klieben used these types of photographs to locate old foundations and footings so that he could more accurately design the buildings and town layout. (Courtesy OCA.)

Four

DE-GHOSTING A GHOST TOWN

THE KNOTT YEARS

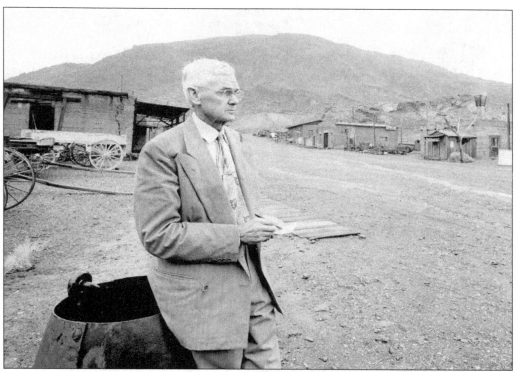

WALTER C. KNOTT. During the reconstruction of Calico, Walter Knott was an active participant in the details of the restoration and a frequent visitor to the town to check on progress. In this image from 1954, Knott is writing notes and assessing the restoration progress along Main Street. (Courtesy OCA.)

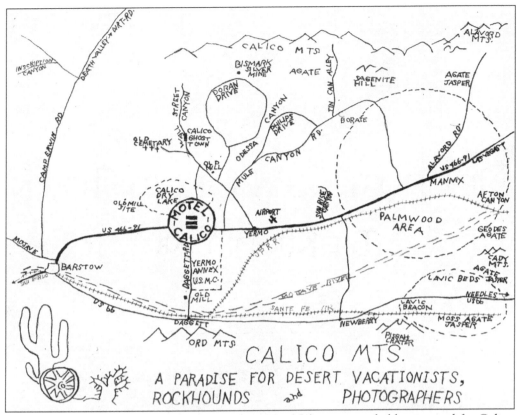

CALICO MTS.
A PARADISE FOR DESERT VACATIONISTS,
ROCKHOUNDS and PHOTOGRAPHERS

CALICO MAP. Given the date of this map (May 5, 1950), it was probably prepared for Calico Days, a festival held in Yermo at the end of May. It also could have been designed either for or by O.A. Russell, who owned the Calico Motel. Even before Walter Knott began his restoration of Calico, thousands enjoyed exploring the area each year. (Courtesy Mojave Desert Archives, Dennis Casebier.)

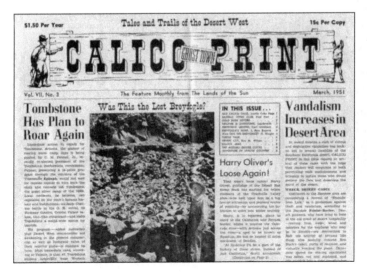

CALICO PRINT, 1951. The early 1950s version of the *Calico Print* was produced by Harold and Lucile Weight. The first 17 monthly issues were published in tabloid format before changing the newspaper to a bimonthly, magazine-type format similar to that of *Desert Magazine* where the Weights had formerly worked. The final issue of the *Calico Print* was issued at the end of 1953. Pictured is the top portion of the March 1951 edition. (Courtesy OCA.)

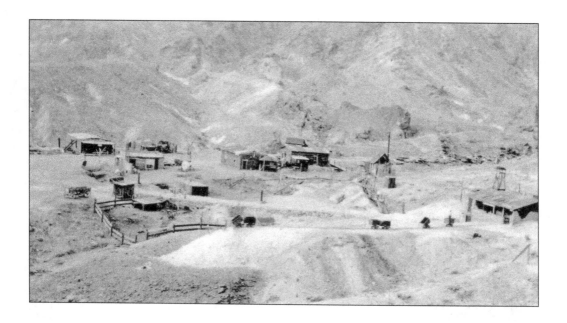

As It Was in 1953. These two images show Calico in 1953. The photograph above, taken from the hillside east of town, shows the Doll House at center right, the Maggie Mine building before it was fully restored (far right), the burro corral (center left), and several abandoned ore carts in the foreground. The image below shows the Stone Front Building (also called Joe's Saloon) as it appeared before restoration. (Both, courtesy OCA.)

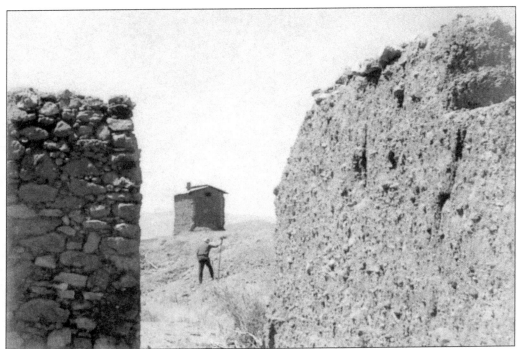

PAUL VON KLIEBEN. Paul von Klieben (1895–1953) was an Austrian artist who immigrated to the United States in the early 20th century. In 1938, Walter Knott hired von Klieben to complete a mural in honor of his grandmother and later to do a variety of artistic jobs at Knott's Berry Farm. Proving to be a world-class artist, von Klieben used his skills to help Knott with the restoration of Calico. In the above image from the early 1950s, he is seen wandering the hillsides of Calico while formulating the designs for various buildings. Below, von Klieben is whittling near the Calico powerhouse. A camera and tripod are at left, likely the property of O.A. Russell, who took the photograph. (Both, courtesy Mojave Desert Archives, Dennis Casebier.)

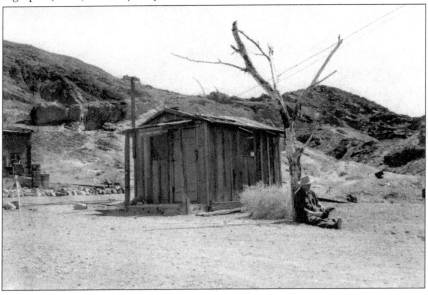

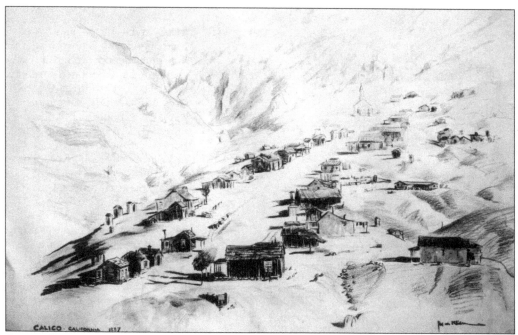

CALICO DESIGNS. When Walter Knott began his restoration of Calico, he had artist Paul von Klieben produce the designs. Von Klieben was the resident artist at Knott's Berry Farm and had a special interest in the Old West. Many of the buildings at Calico were designed by von Klieben using old photographs and maps and by visiting deserted western towns such as Rhyolite and Bodie. A couple of von Klieben's concept drawings of Calico are shown in these two images from around 1950. The above drawing represents Calico as it looked in 1887. The vintage postcard below shows von Klieben's more notional concept of Calico on a Saturday night in 1881. The large, humorous, colorful mural still hangs behind the sarsaparilla bar at the Knott's Berry Farm Calico Saloon. (Both, courtesy OCA.)

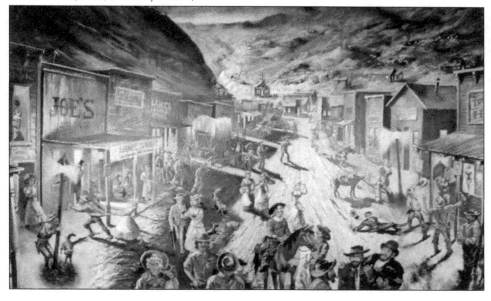

March 1951

Miss De Lill
Tombstone, Arizona
Dear Miss De Lill:

As the designer about to undertake the
re-construction and promotion of Old Calico
California's once greatest Silver Camp,
I would like to approach you with the following
request.

Your name is on the tongue of everyone who
visits the camp, stories surrounding it are
told and retold until today it is practically
synonimous with Calico.

With your gracious permission I would, along with
rebuilding the town also wish to recreate Diamond
Lill by selecting a girl as hostess of the Camp
who in her appearance comes closest to your person
in the Days of the Calicos.

If you will please grant me this permission, then I
would like to ask you for the loan of one of your
photographs of that period. From it I will then have
a copy made and return the original to you promptly and
safely. With this I should also have a description of the
color of your hair and eyes as well as your color prefer-
ence in dress.

MADAME DE LILL. The story of Madame De Lill is unverified, but some accounts indicate that she owned and operated a saloon on Calico's Main Street. As the story goes, De Lill was anxious to rid herself of her philandering husband, Bill, and concocted a brazen scheme to scare him out of town. With the help of some of the local miners, her plan worked perfectly and he was never seen in Calico again. In the late 1940s and early 1950s when Paul von Klieben was doing much of the design work for the Knott family reconstruction of Calico, he apparently thought the Miss De Mill tales were true enough to attempt to contact her for advice. As shown in this letter from 1951, Miss De Lill was certainly a subject of Calico's history—real or perceived. (Both, courtesy OCA.)

Later, after sufficient work in the reconstruction
has been done, an official opening date will be
set, during which as the highlight of that day's cele-
bration, I hope you will honor Calico with your
presence, joining others living today, who were part
of the town during that period.

May I thank you for your kindness of a reply.

Respectfully,

Paul v. Klieben

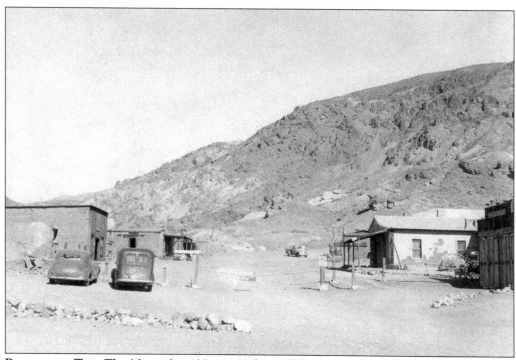

POPULATION TWO. This November 1951 image shows the Calico Main Street looking to the north a few months after Walter Knott purchased the property. A sign on the gatepost indicates the elevation of the town as 3,300 feet and the population as two. (Courtesy OCA.)

CALICO CLEANUP. Calico's restoration by the Knott family began toward the end of 1951. This photograph does not show any new construction, but numerous trucks and workers are on the site, and much of the debris from decades of minimal care has been removed. (Courtesy OCA.)

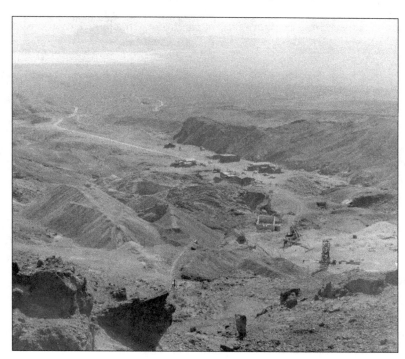

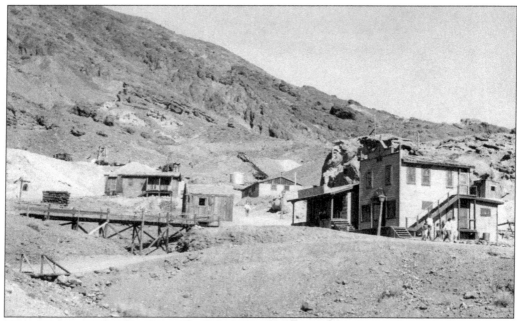

TOWN VIEWS, 1950s. By the mid-to-late 1950s, the Knott reconstruction was well underway. Above, mine tailings, ruins of the Silver King mine chute, and the 1940s-era Hyena House are seen at center. To the right are two 1950s-era constructions. The two-story building was patterned on the old Cosmopolitan Hotel from the 1880s and was used as the Sweets Shoppe. The sign above the adjacent building reads, "McCulloch's Supply Warehouse," which housed a basket shop. Both buildings were destroyed by a small fire in 2001 but rebuilt by 2002. In the photograph below looking toward Wall Street Canyon, a burro train is being led down Main Street near the Lane House. The original two-door, rammed-earth adobe outhouse is in the center foreground. (Both, courtesy OCA.)

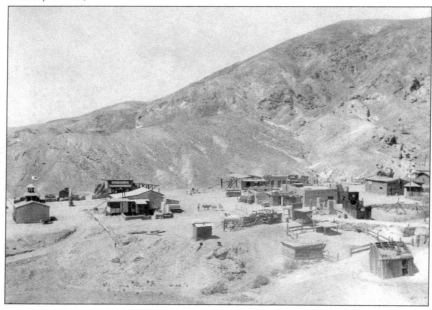

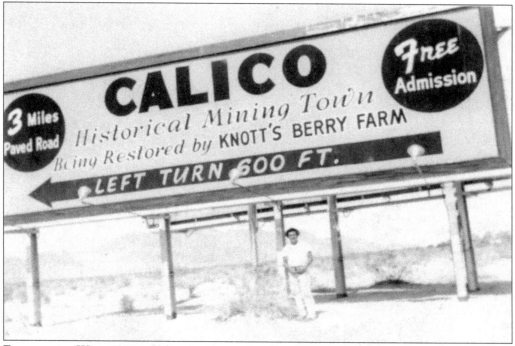

FINDING THE WAY, 1950s. Calico had been abandoned, or nearly so, for so long that new signs had to be constructed to show visitors the way. The large billboard-type sign above was located near the turn-off from what is now known as Ghost Town Road. The man beneath the billboard is unidentified, but he is seen in similar photographs painting the sign. Once past the cemetery, visitors were directed to enter Calico's Main Street beneath a vintage-looking sign providing tidbits of historical information. (Both, courtesy OCA.)

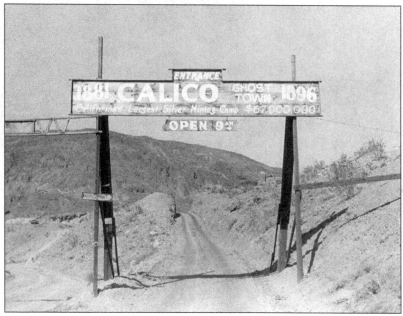

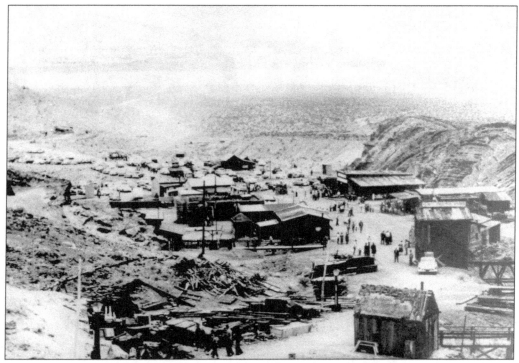

REBUILDING CALICO. In these two images from the early 1950s, Main Street is seen during reconstruction from the north (above) and south (below). Both show piles of debris and construction materials along the east side of the street. As seen above, people continued to visit Calico to watch the progress throughout the rebuilding process. (Both, courtesy OCA.)

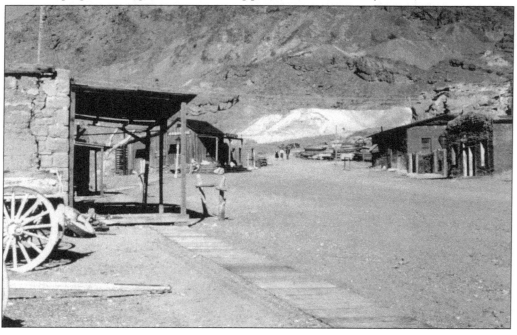

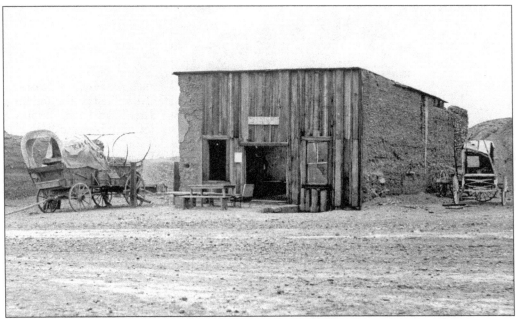

LANES MERCANTILE RESTORATION. After their marriage on June 7, 1893, John and Lucy Lane opened a general merchandise store on Calico's Main Street. The couple left Calico in 1899, but returned in 1916 and made the old store their home. A few years later, the Lanes moved into the old courthouse and post office building, where Lucy lived off and on until her death in 1967 at the age of 92. At the time Walter Knott purchased Calico, the Lane Mercantile Store appeared as shown in the 1951 photograph above. The building was little more than a shell of its former self, but it became one of Calico's most active businesses within a few years. The image below from February 1956 shows visitors enjoying a warm winter day at the restored store. (Both, courtesy OCA.)

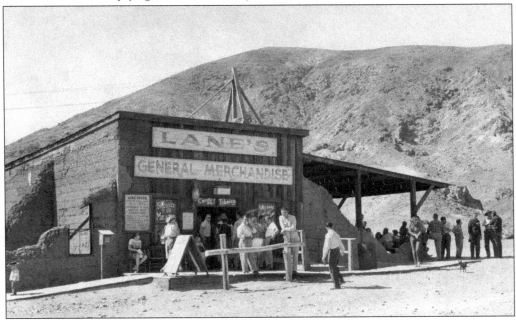

FRED AND GLADYS NOLLER. Calico Fred Noller and his wife, Gladys, were fixtures at Calico between 1952 and 1958. Born in Arizona Territory in 1903, Calico Fred was a cowhand, builder, miner, merchant marine, and commercial artist before being hired by the Knott family as a jack-of-all-trades and to add "atmosphere" to the town. The photograph at left was taken in the mid-1950s while the Nollers were living in a small home south of town and helping with the restoration. Below, Gladys is posing outside their home with their dog Miner. (Left, courtesy OCA; below, courtesy Mojave Desert Archives, Dennis Casebier.)

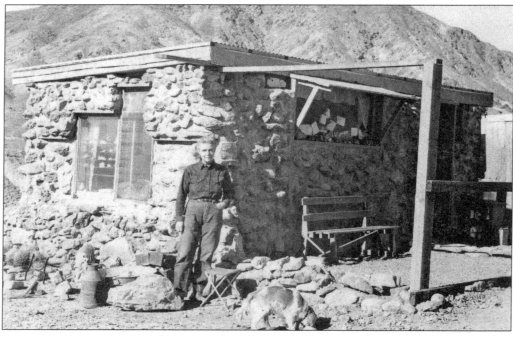

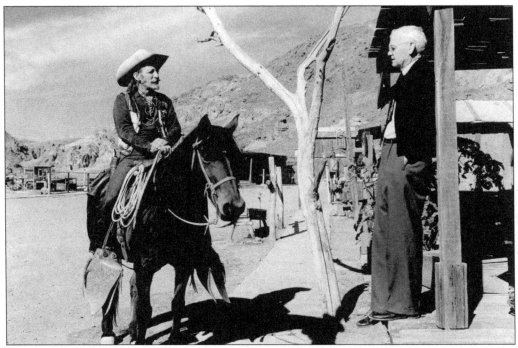

Conferring with Calico Fred. Walter Knott (right) and Calico Fred Noller are seen in this 1954 image conferring over the progress of the Calico restoration. Noller handled day-to-day supervision of the construction activities, but Knott was very hands-on and visited the town often. (Courtesy OCA.)

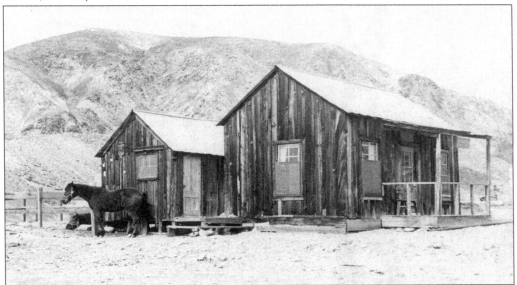

Marshal's Office. In 1953, the original Zenda Gold Mining Company buildings were used by Walter Knott's construction manager Fred Noller as the construction headquarters. Noller's horses, which are seen in several images from the era, are tied outside, and the sign on the front building reads "Marshal's Office." (Courtesy OCA.)

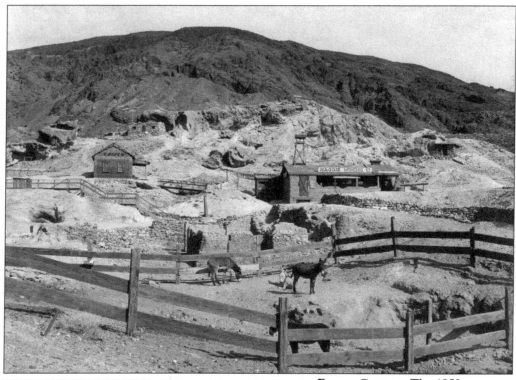

BURRO CORRAL. The 1950s-era Calico corral was located below the Maggie Mine entrance and adjacent to the old Chinatown (adobe ruins, center). The area was known historically as Jackass Gulch. Burros have always been a part of Calico's history, first as pack animals to bring ore down from the more inaccessible mines, and later to carry heavy loads during the rebuilding of the town. At left is a baby burro within a barbwire enclosure near the corral. (Both, courtesy OCA.)

MINE SHAFT RESCUE. One of the earliest projects in the restoration of Calico was to inspect and close thousands of feet of mine shafts and hundreds of hazardous holes. The Knott family asked Calico Fred Noller to oversee the work, among other tasks. During the months that it took to make Calico safer for visitors, Noller was called upon to enter many of the dangerous areas. None, however, was more daring than his rescue of a little dog that had fallen into a mine shaft. Named Miner, the dog appears in numerous photographs from this period with Noller and his wife, Gladys. It is not clear whether the dog was adopted by the Nollers after its rescue or whether it belonged to the Nollers all along and just had an unfortunate accident. (Both, courtesy OCA.)

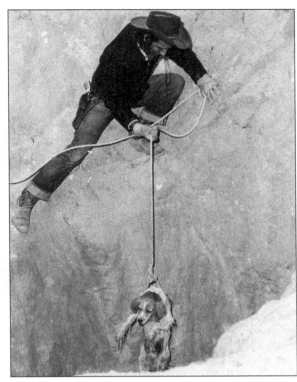

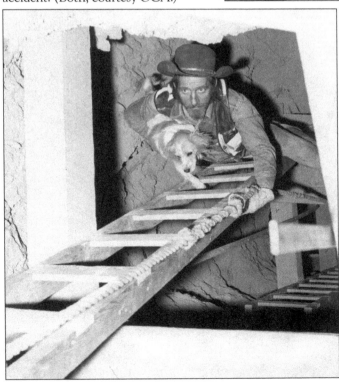

DOLL HOUSE. The Calico Doll House was a Walter Knott construction. The small building, shown here in 1953, was probably designed by Paul von Klieben to resemble a miner's cabin. Over the years, it has been used as a residence by various Calico street characters, including Tumbleweed Harris and Sheriff Lonesome George Goldsmith and his wife, Nancy Jean, all of whom are buried in the Calico cemetery. (Courtesy Mojave Desert Archives, Dennis Casebier.)

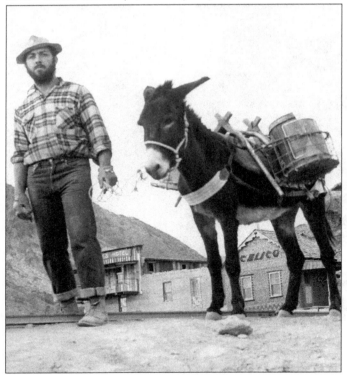

DOLLY IN ACTION. In this 1950s image, "Dolly" is carrying cement to help build a miner's home in the hills above town. Dolly's partner is Joe Folk. (Courtesy OCA.)

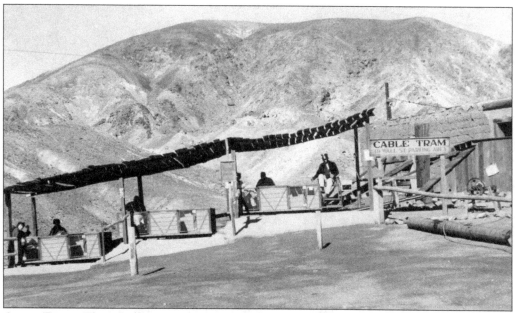

CABLE TRAM. The Lucille Mining Company Tram was a set of wooden ore cars that carried visitors back and forth from the Wall Street Canyon parking lot to a station near Main Street. These two images show the upper tram station (above) and the lower parking lot area and narrow gauge rail path along the hillside. Visitors ambitious enough to walk the steep canyon wall could take the adjacent zigzag path (below center). (Both, courtesy OCA.)

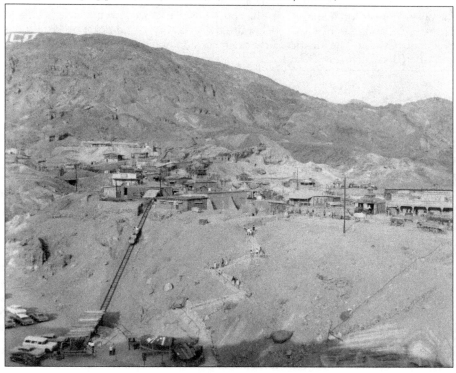

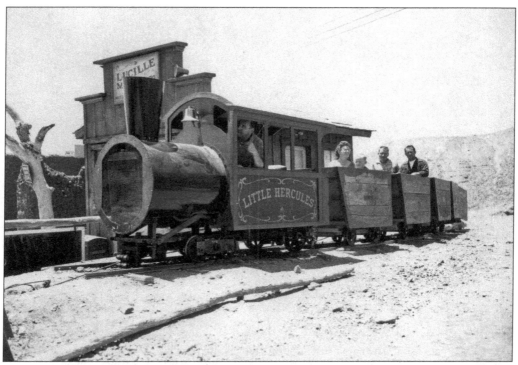

TRAIN STATIONS. The Lucille Mining Company Tram and the Calico & Odessa Railroad were built, owned, and operated by Shafe-Malcom Enterprises; Boyd Clark and his wife, Margaret, were the onsite concession managers. In the above image is Little Hercules, the Lucille Mining Company engine, and passenger cars. Below are the small depot and ticket office and the train of the Calico & Odessa. The identity of the engineer standing by the train is not confirmed but may be Clark. (Both, courtesy OCA.)

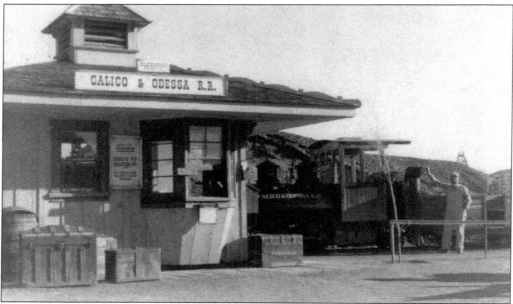

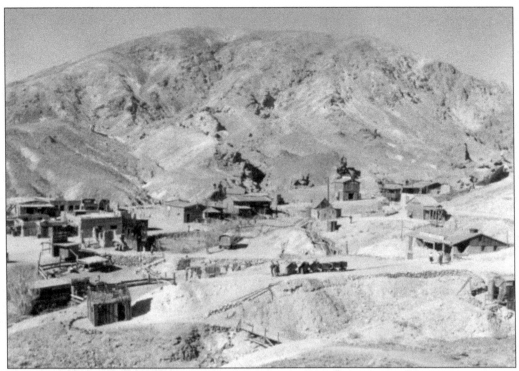

CALICO & ODESSA DEVELOPMENT. Construction of the 30-inch narrow gauge Calico & Odessa Railroad began in late 1957. In the January 1958 photograph above, the area has been prepared for the track and station, but the construction has not yet begun. In the image below from the 1970s, the track and 100-foot-long trestle bridging Jackass Gulch are active and ready for visitors to take an excursion. The railroad was designed to wind through a part of the Calico Hills visible to visitors only from the train, passing by old mine shafts once active with silver miners. (Both, courtesy OCA.)

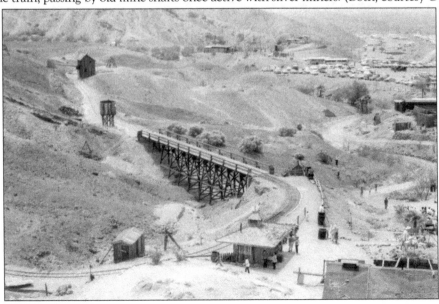

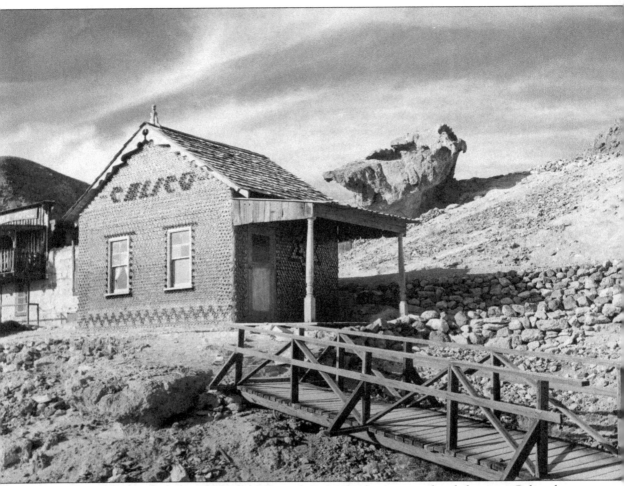

CALICO BOTTLE HOUSE, 1954. There are no historical references to a bottle house at Calico, but the use of alternative building materials—bottles, tin cans, barrels, dynamite boxes—was not uncommon in mining towns and other remote areas. Since saloons were prolific in most mining towns, there was always a plentiful supply of discarded bottles. Among others, bottle houses have been recorded in Texas, Ohio, North Carolina, Michigan, and Mississippi. One of the most well-known in the western United States is in Rhyolite, Nevada. During reconstruction, Walter Knott visited Rhyolite, photographed the bottle house, and used the concept at Calico, although on a smaller scale. The Calico bottle house is constructed of 5,419 bottles of varying sizes and colors. (Courtesy OCA.)

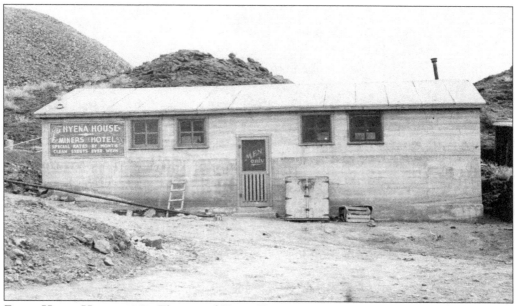

ZENDA HYENA HOUSE, 1953. The second Hyena House was constructed of board-formed concrete. It was built in the 1940s when the Zenda Gold Mining Company was recovering silver from old mine tailings. Originally used to store mill processing materials, the building was renovated in 1953 for use as a cookhouse for the craftsmen working on Walter Knott's reconstruction of Calico. (Courtesy OCA.)

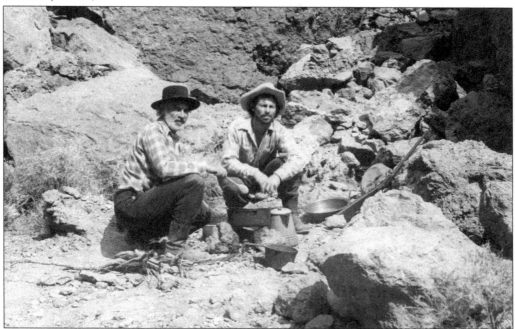

FILM MAKING. Over the years, the movie industry has used the Calico area as the setting for numerous productions. In this image from 1954, two unidentified actors are portraying old prospectors in search of a silver strike. The title of this particular film was not noted. (Courtesy OCA.)

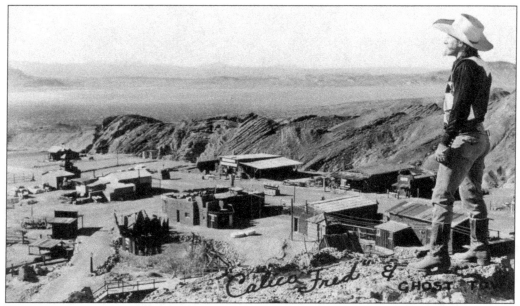

Looking over the Progress. In this vintage postcard, Fred Noller is overlooking the restoration of Calico from a rocky ledge above town. At the far left center, 1950s-era automobiles are seen, and most of the debris from decades of marginal use and neglect has already been removed. (Author's personal collection.)

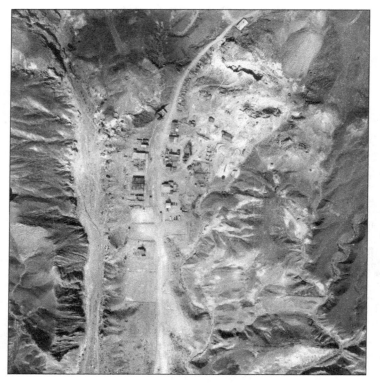

From above in 1953. This image was probably commissioned by Walter Knott to monitor restoration progress. Piles of the cleaned-up debris and construction materials are seen lining the right side of north Main Street, and areas have been cleared for parking and new construction. This image is a good view of the entire town, old foundation locations, and Wall Street Canyon (left). The distinctive rectangular outline of the Zenda-era Hyena House is near the top center. (Courtesy MRVM.)

THE ASSAY OFFICE. In Calico's glory days, the Assay Office analyzed and valued ore samples. In reconstructed Calico, the Assay Office was first operated by George and Ginny Dotson, who not only scoured the hills for minerals to polish, but also made jewelry from the polished stones and offered visitors information on the local minerals. At right in November 1952, Gladys Noller and the Nollers' dog Miner are spending the day in the Assay Office. The image below of visitors at the Assay Office is from the late 1950s. (Right, courtesy Mojave Desert Archives, Dennis Casebier; below, courtesy OCA.)

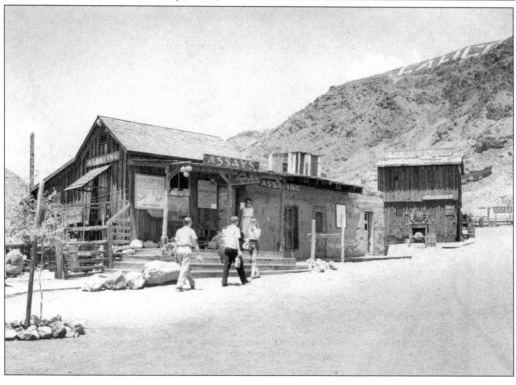

WATER WAGON. Typical of early desert communities, water was transported by a tank wagon, similar to the one shown here in 1954. In the late 1800s, tank wagons were pulled by one to three horses, depending on the size of the tank. This wagon remains parked along Main Street as a reminder of the early years when there was no piped water in the town. (Courtesy OCA.)

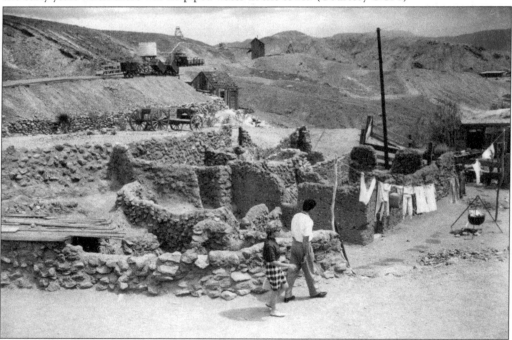

CHINATOWN RUINS. Although these visitors to Calico in the 1950s found only ruins of the former Chinatown, in its heyday, more than 40 Chinese lived and worked there. Histories reveal that the community operated restaurants and laundries, and their leader Yung Hen owned and operated four boardinghouses. A good businessman, Yung Hen grubstaked several prospectors and often extended credit to miners until they could find steady work. (Courtesy OCA.)

BUILDING THE SCHOOL HOUSE. The replica of Calico's second schoolhouse is at the same location, but is one-third smaller than the original building. Pictured at right in April 1955, Bill Niles and Ted Grubb, who were part of the schoolhouse construction crew, are posing in front of the partially finished building. The finished product is seen below in the early 1960s. (Right, courtesy Mojave Desert Archives, Dennis Casebier; below, courtesy OCA.)

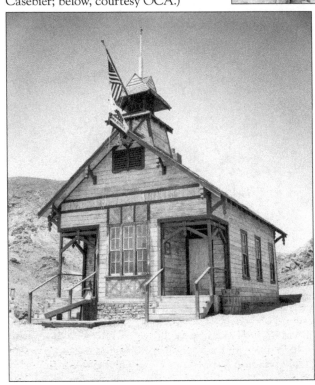

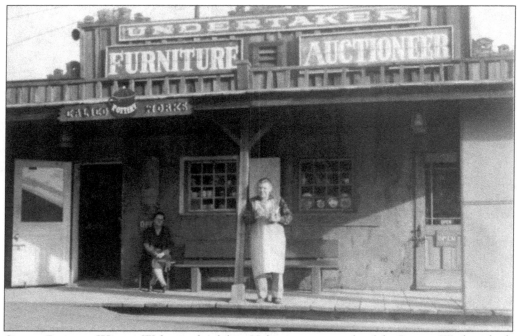

CALICO POTTERY WORKS. Walter and Adaline Hale are seen outside of the Pottery Works, which they opened at Calico in 1956. Housed in the Undertaker's Building, the shop offered original items, many of which were designed, molded, and fired on the premises. According to the 1962 *Knotty Post*, the Hales traveled to California from the Midwest in 1938 and never left. (Courtesy OCA.)

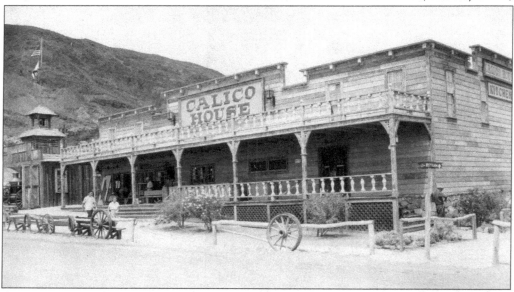

CALICO HOUSE. When Walter Knott restored Calico, the Calico House Kitchen was one of the last buildings completed (1956–1957). It was first operated by Joe Lopez and his wife, Jean, who offered a variety of sandwiches, beef stew, ham steak, and, as many a visitor would say, "a very tasty strawberry pie." Since completion, the Calico House has been one of the longest continuously operated businesses in Calico. (Courtesy OCA.)

BLACKSMITH'S SHOP, 1953. The C&H Smelter building is a Walter Knott construction. Since it was completed in the early 1950s, the building has been used primarily as the Calico blacksmith's shop. Authentic blacksmith tools and equipment are housed in the building, and demonstrations are held during special events by Calico's official, 17th-generation blacksmith. (Courtesy OCA.).

PROSPECTING FOR GOLD. Although traces of gold were found in other areas, the Burcham Mine was the only mine in the Calico Hills with enough gold to make a profit. First named the Total Wreck, the mine was discovered in 1883 and abandoned during World War II. Pictured here in 1954, Lloyd Culver is checking for gold traces near the Burcham entrance. Remnants of narrow gauge track are visible in the mine floor. (Courtesy OCA.)

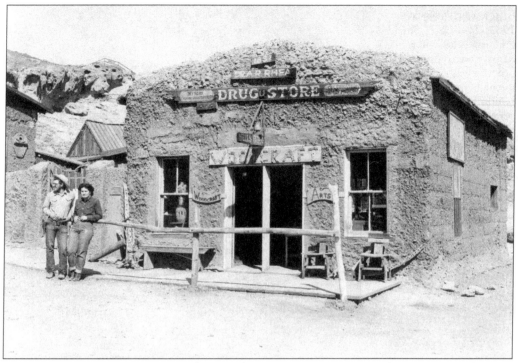

RHEA'S DRUGSTORE RESTORED. Dr. Albert R. Rhea's Drugstore is one of the few rammed-earth adobe buildings remaining in Calico from the 1880s. The building was rehabilitated by Walter Knott in the 1950s and is shown here in the same era. The man and woman leaning on the hitching post are not identified. At the time of this photograph, the shop operators sold arts and crafts made of wood. The building has been used as Lil's Saloon since about 1954. (Courtesy OCA.)

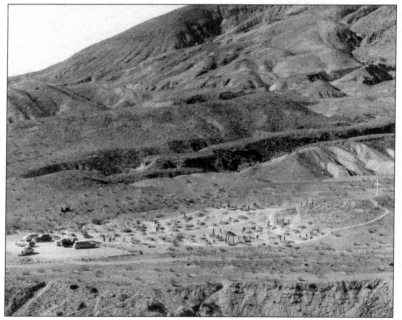

VISITING THE CEMETERY. In this image from the mid-1950s, many of the original wood markers and a few of the picket fence enclosures are still present in the Calico cemetery. A tall grave marker with a shingle roof that appears in very early images of the cemetery is in the lower center foreground. (Courtesy OCA.)

WALL STREET TIPPLE. The entrance to Wall Street Canyon is seen here in 1954. Within and crossing the canyon are the remains of a footbridge and the Silver King Mine tipple where ore cars were "tipped" to empty their contents into bins or cars. The photograph was taken by O.A. Russell, who was hired by Walter Knott to record many of the original and reconstructed features at Calico. (Courtesy OCA.)

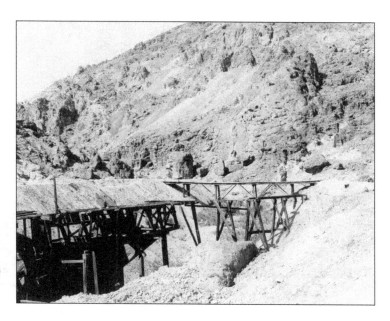

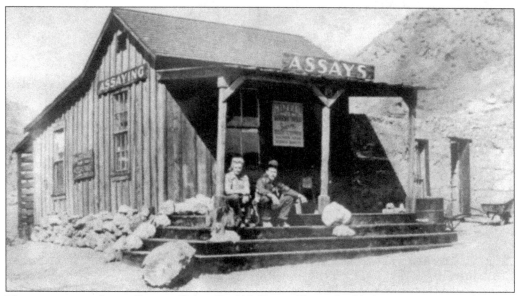

NOLLERS AT THE ASSAY OFFICE. Calico Fred Noller and his wife, Gladys, are resting on the steps of the Calico Assay Office in the mid-to-late 1950s. During their years in Calico, Gladys often worked in the office. Miner, their dog and the subject of Fred's daring rescue, is resting on the steps with them. (Courtesy OCA.)

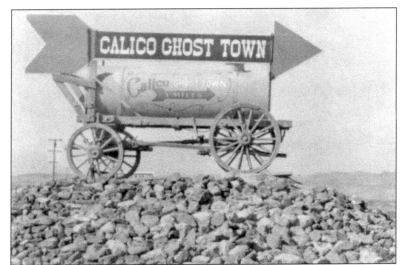

THIS WAY TO CALICO. This 1950s-era sign painted on a water wagon points the way to Calico from what is now Ghost Town Road. The sign was placed about three miles from the main entrance. (Courtesy OCA.)

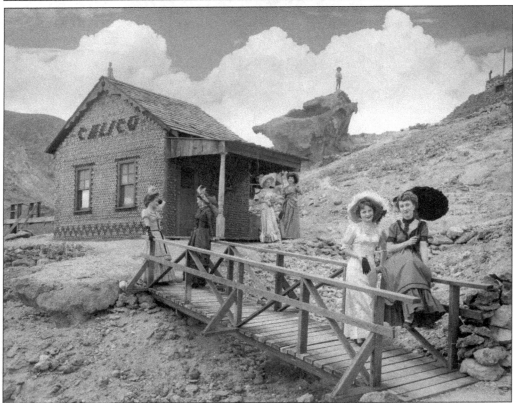

COSTUMED LADIES. Between the 1950s and 1970s, costumed characters (sometimes called street characters) were often seen at Calico. The characters acted as greeters and offered bits of history about the town to visitors. Here, finely dressed ladies are walking along the boardwalk near the Doll House and Bottle House as Calico Fred Noller, the town's unofficial marshal, watches from the rock formation above town. Costumed characters are still seen at Calico, especially on event days. (Courtesy OCA.)

CALICO PRINT SHOP. The above image was taken in the 1950s before the ruins were fully restored as the Calico Print Shop. The rammed-earth adobe ruins were stabilized and expanded using concrete, and the old carriage parked to the side for effect. Ray Milligan operated the business in the 1950s and 1960s and provided copies of the original *Calico Print* newspaper for visitors to read. Milligan also painted many of the rustic signs found at Calico, including the one over the porch in both of these images. (Both, courtesy OCA.)

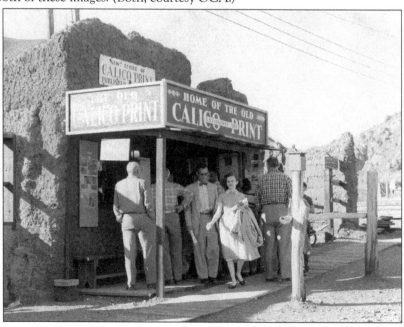

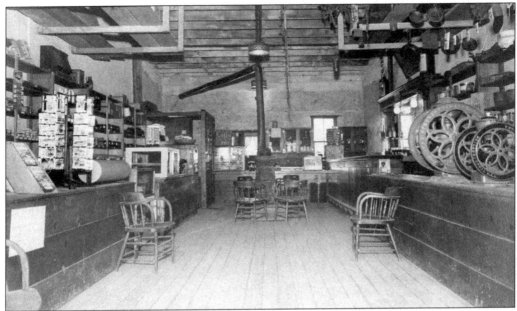

A PLACE FOR GATHERING. The interior of the restored Lane's General Merchandise Store is shown above in 1954. General stores were not just places to resupply, but also social gathering places. In the early mining days, Lane's carried general provisions as well as mining supplies and equipment. A bank was never built in Calico, so John Lane also stored bags of silver in the store's basement in later years. Although some of the features of the store were changed during restoration, the potbellied stove and post office window remained the same. Below, the Model T Automobile Club of Southern California poses in front of Lane's store during a 1955 visit to Calico. The store was a popular rest stop for the club on their annual treks into the desert. (Both, courtesy OCA.)

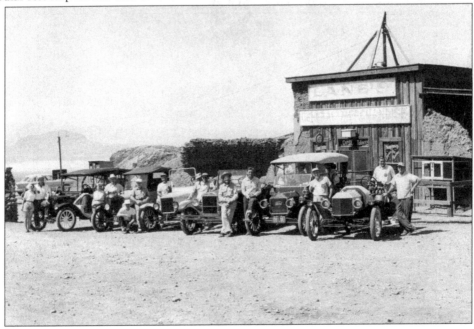

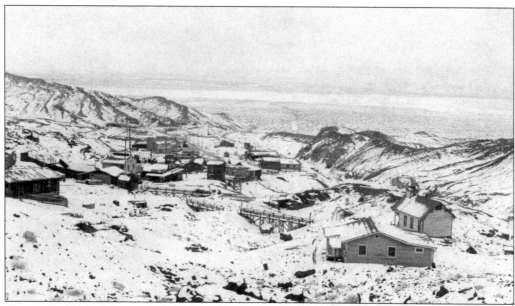

CALICO BLIZZARD. Given the less than four inches of precipitation that falls in the Calico area annually, snow is a rare occurrence. These two images show the two to three inches of snow that blanketed the town and the surrounding communities on January 29, 1957. According to weather records, the high on that day was 37 degrees. Above is a view of snow-covered Calico from the hillside above town. Below is a portion of Main Street, including the Calico Print Shop, with the Calico Hills in the background. (Both, courtesy OCA.)

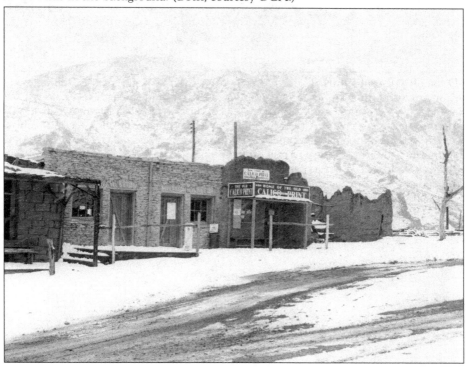

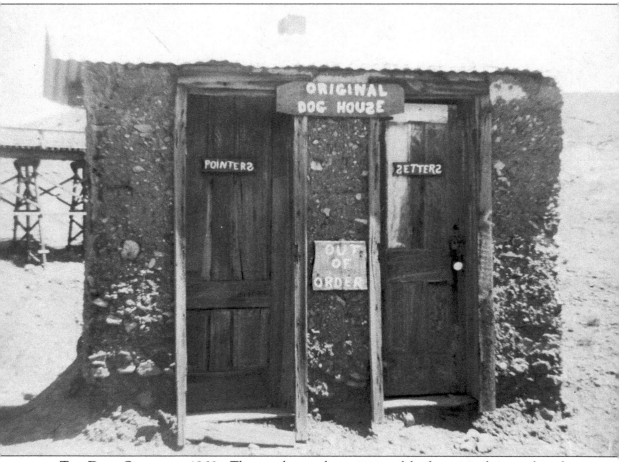

Two-Door Outhouse, 1960s. The two-door outhouse is one of the few original rammed-earth adobe constructions from the 1880s remaining in Calico. Rammed-earth construction involves pressing moist soil—usually containing rocks, sand, and clay—into a wood frame where it is allowed to harden in the summer heat. Although similar to adobe brick, this construction technique is stronger and has been used for thousands of years in structures such as the Great Wall of China and European castles. In addition to rock, the outhouse at Calico was reinforced with bits and pieces of household and construction items. Still visible in the walls are fragments of bottle glass in various colors, hand-wrought nails, wire, pottery shards, and part of a cast-iron stove leg. The trestle of the Calico & Odessa Railroad is in the background. (Courtesy OCA.)

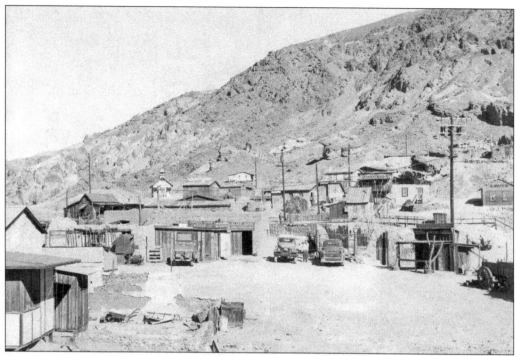

CALICO ON THE HILL. In the above image dated January 21, 1958, signs over the two buildings in the center read, "Wagon Shop J. Moser Prop." and "Black Smith M.L. Jones and Son." The sign on the small building to the right of the two vintage trucks indicates the location of the Cactus Corral. After this photograph was taken, the name *Calico* was painted on the hillside above the town. The below image from about 1959 shows the newly painted large white letters clearly visible near the top of King Mountain. The letters have since become a local landmark for both visitors on the ground and passing aircraft. (Both, courtesy OCA.)

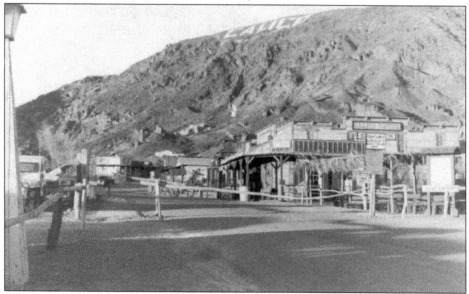

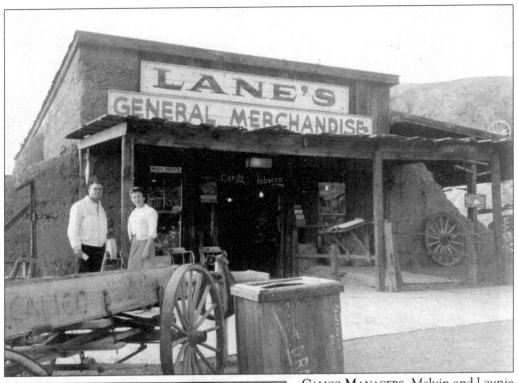

CALICO MANAGERS. Melvin and Launie Huber, shown here in 1962, worked for Walter Knott at Knott's Berry Farm. They met while working there and married in 1956. The Hubers and their two sons moved to Calico and became the managers of both the town and Lane's General Store. (Courtesy OCA.)

CALICO'S MOST FAMOUS RESIDENT. When this photograph of Lucy Bell King Lane was taken in 1958, she was Calico's oldest resident. Settling in Calico with her family in 1884 at the age of 10, Lucy married John Lane at 18, and lived off and on her entire life on Calico's Main Street. Lane is shown here in front of the entrance to the Maggie Mine around the age of 83. (Courtesy OCA.).

TUMBLEWEED HARRIS.
Noteworthy among the many Calico street characters was Donald Willard "Tumbleweed" Harris (1906–1979), who worked in the 1950s at both Calico and Knott's Berry Farm. Born in New Jersey, Harris earned his nickname by working at a variety of odd jobs and, as one friend remarked, by "wandering all over the desert like a tumbleweed." The day before he died, a photograph of Harris was placed in the Calico Town Hall; he was one of the first five honored there. At right, Harris (right) is posing in the 1970s with Cactus Dale Brown, who later remarked that Harris had treated him like a son. Harris is buried in the Calico cemetery; at his request, each of the funeral attendees wore their street character costumes. (Both, courtesy Betty J. Stohler.)

A Sticky Place. As the stories go, "there was one place at Calico where you could really get stuck"—the Cactus Corral. Interviewed in 1962 for the *Knotty Post*, caretaker Ted Hutcheson said he had so many kinds of cactus in his corral that he would not even guess at the number. Located in a low gully next to Chinatown, the Cactus Corral once had a mischievous sign saying, "Touch All You Want." (Courtesy OCA.)

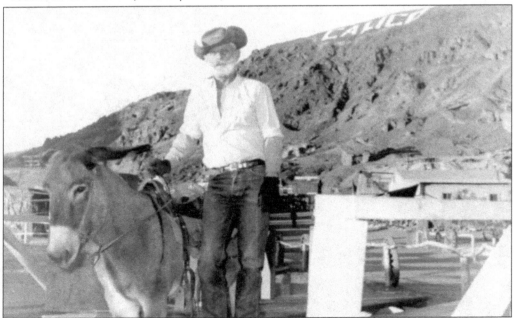

Uncle Don's Burro Train. Born in Arkansas, Uncle Don Hughes moved to Calico in October 1961 to tend a string of burros and guide "burro train" rides through the Calico hills. A colorful addition to Calico's restoration years, Uncle Don was easily recognizable because of his bushy beard and red underwear. He is buried in the Calico cemetery. (Courtesy OCA.)

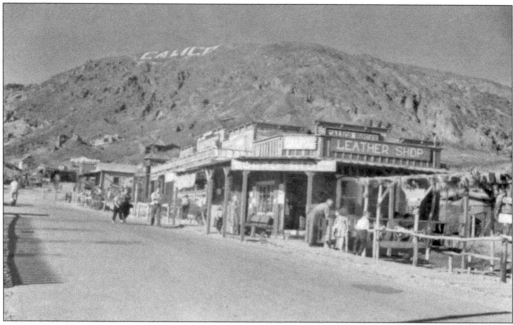

CALICO RESTORED. Although improvements to Calico continued well past these two 1959 photographs, most of Walter Knott's restoration work was complete. The restaurant was the last building constructed, and all of the concessions were staffed and operating full time. Above is a late afternoon view of Main Street looking north; below, the Calico & Odessa train is parked by the station above the ruins of Chinatown, complete with various articles of clothing hanging out to dry near the old laundry. (Both, courtesy OCA.)

THE KNOTTY POST. The *Knotty Post* was published and printed by the employees of Knott's Berry Farm. Although the publication was primarily focused on the Buena Park activities, there were several Calico issues as well. The front and back covers from the January/February 1962 Calico edition are shown here. The front shows visitors strolling along Main Street on a crisp winter day, and the back provides a diagram of the buildings and shops that were available for visitors to enjoy. This particular issue included articles on the history and geology of Calico, photographs and stories about shop owners, a brief description of the schoolhouse and cemetery, and an article about the Krazee House, "one of Calico's newer constructions." (Both, courtesy OCA.)

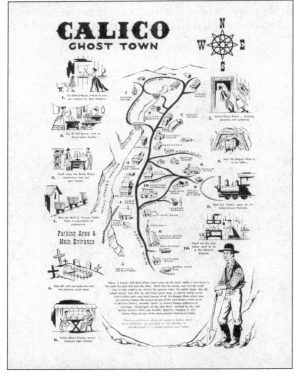

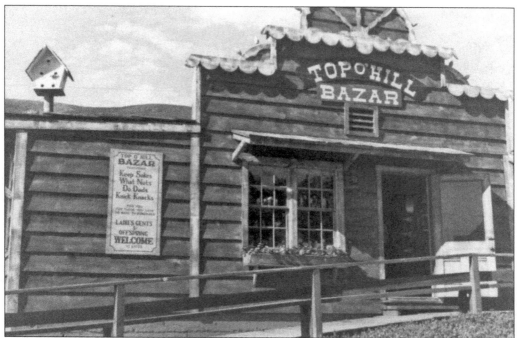

TOP O' HILL BAZAR. The Knott reconstruction of Calico included new and restored buildings designed to house merchants and eateries for visitors. Walt and Rose Applebury opened the Top O' Hill Bazar in one of the new buildings in 1958, and Walt became the town marshal. Located near the footbridge to the Calico schoolhouse, Top O' Hill Bazar was a souvenir shop that carried a variety of items—everything from "soft drinks to mousetraps." Seen below in 1962, Rose is replacing the chimney on a replica 1800s-era oil lamp. (Both, courtesy OCA.)

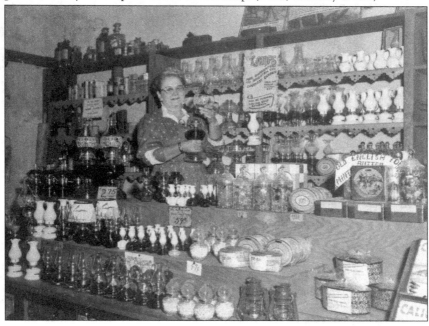

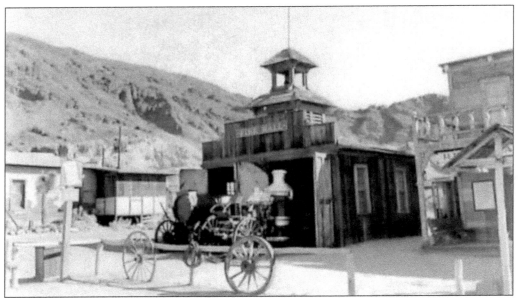

FIRE HALL AND STEAM ENGINE, 1960s. After two devastating fires, a well was installed and a horse-drawn steam engine was purchased to augment Calico's bucket brigade. The wood-frame fire hall is a Knott reconstruction. Calico's current fire engine was manufactured by the La France Manufacturing Company of Elmira, New York, in about 1896. By 1916, horse-drawn engines were replaced with gasoline-powered engines. Depending on the size of the boiler, steam-fired engines could discharge 350–750 gallons of water per minute. (Courtesy OCA.)

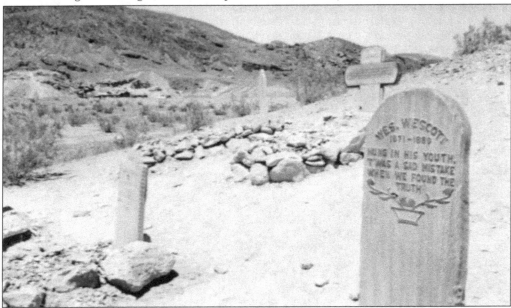

CEMETERY IN THE 1960s. This photograph shows the Calico cemetery as it appeared in the 1960s. Wes Wescott, whose grave marker is seen at right, appears on San Bernardino County cemetery records, and the birth and death dates are accurate; however, there are no verified historical records of any hangings having taken place in Calico. (Author's personal collection.)

NORTH MAIN STREET CROWD. The original Mystery Shack at Calico was at the upper end of Main Street. Shown here in the late 1960s, the building was destroyed along with four other buildings and a popcorn wagon in July 2001 but was rebuilt by the following year. The popular attraction, which is still active, allows visitors to experience various optical illusions, including water mysteriously running uphill. (Courtesy OCA.)

HORSE-DRAWN HEARSE. Horse-drawn hearses were first used in the 17th century and remained in use until the first decade of the 20th century when they were replaced by motorized versions. Glass-sided hearses, such as the one pictured here in Calico in the 1960s, were particularly popular, as people were always anxious to view the coffin. (Author's personal collection.)

A Stroll down Main Street. Visitors are strolling down upper Main Street in the late 1960s. The couple in the center is passing McCulloch's Supply Warehouse, which was operated as a basket shop. The adjacent spice and sweet shop displays the distinctive false-front design patterned after the old Cosmopolitan Hotel. (Courtesy OCA.)

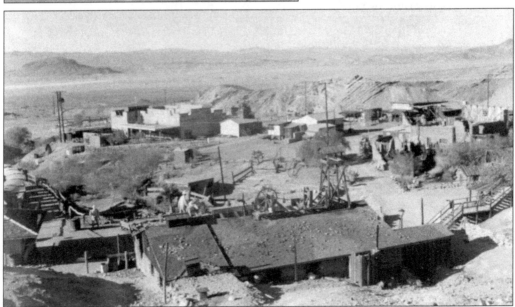

The 1960s Landscape. At the time that Walter Knott donated Calico to the County of San Bernardino, the landscape looked much like it does in this photograph from 1969. The image provides a good overview of the completed restoration, showing the roof of the Maggie Mine in the foreground, the large Calico House Restaurant (left center), and the tilted geology of Wall Street Canyon at rear center. (Courtesy OCA.)

DEDICATION CEREMONY. Walter and Cordelia Knott are shown posing by the dedication plaque (above) and greeting San Bernardino County dignitaries (below), including county supervisor Ross Dana. The Knotts donated Calico and adjacent acreage to San Bernardino County for its current use as a recreation center and park. By this time, Calico had become a popular tourist attraction hosting thousands of visitors each year. (Both, courtesy MRVM.)

Visit us at
arcadiapublishing.com